TAKE THREE COLOURS

WATERCOLOUR
MOUNTAINS

Start to paint with 3 colours, 3 brushes and 9 easy projects

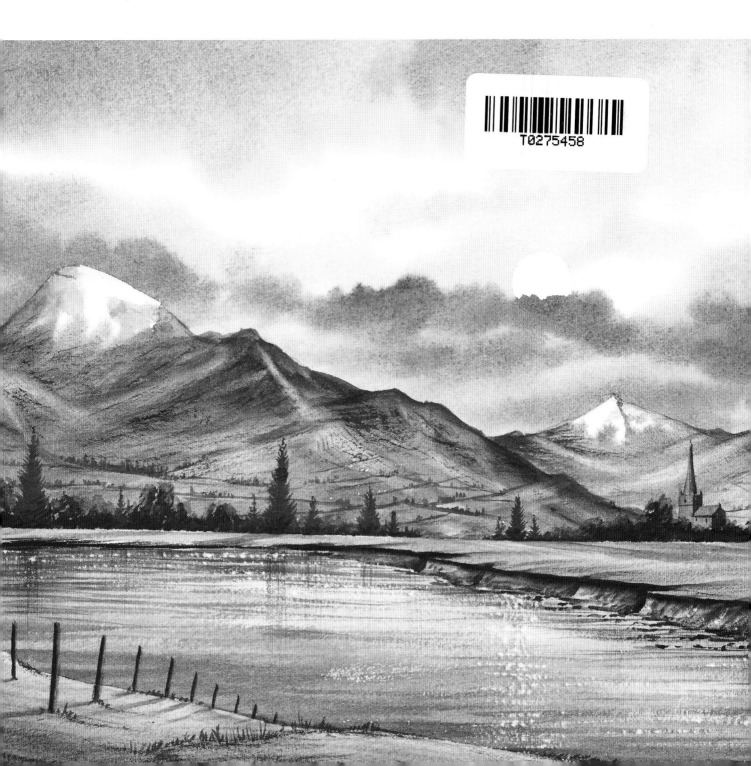

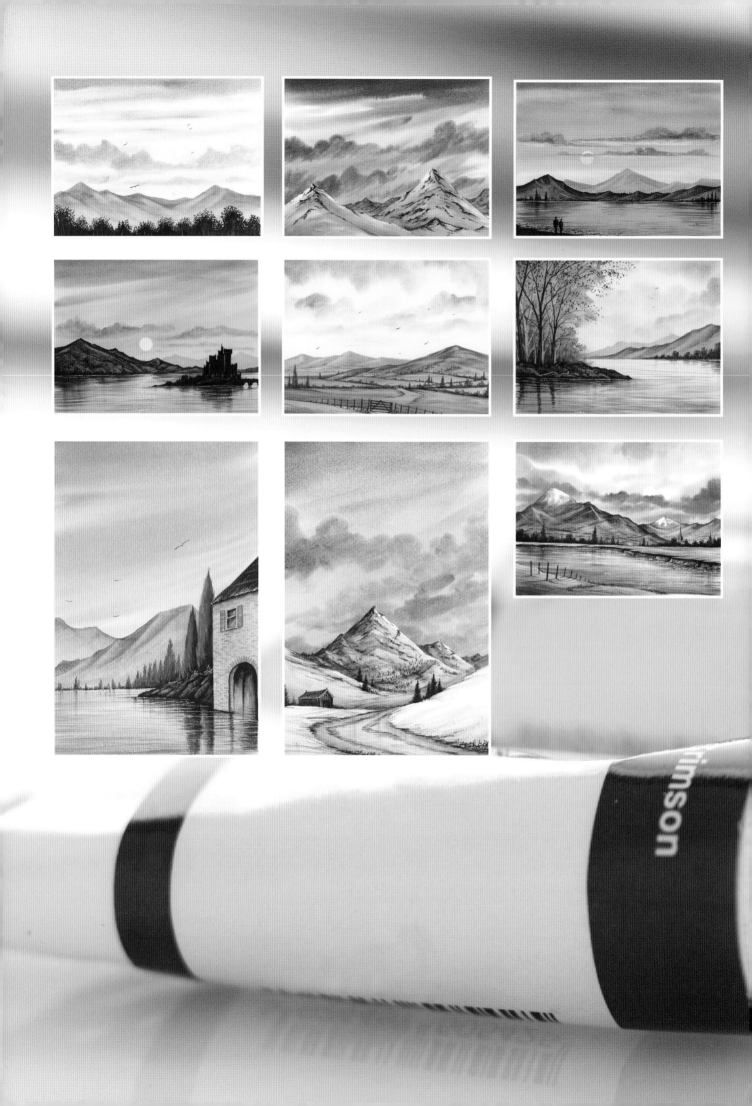

WATERCOLOUR
MOUNTAINS

Start to paint with 3 colours, 3 brushes and 9 easy projects

Matthew Palmer

SEARCH PRESS

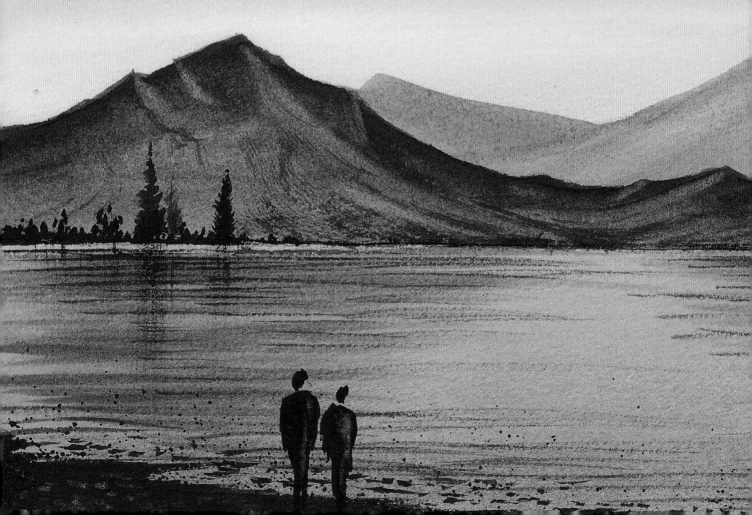

First published in 2019

Search Press Limited
Wellwood, North Farm Road,
Tunbridge Wells, Kent TN2 3DR

Reprinted 2020, 2021

Text copyright © Matthew Palmer 2019

Photographs by Paul Bricknell at Search Press Studios

Photographs and design copyright © Search Press Ltd. 2019

ISBN 978-1-78221-684-1

The Publishers and author can accept no responsibility for any
consequences arising from the information, advice or instructions given
in this publication.

Suppliers
If you have difficulty in obtaining any of the materials and equipment
mentioned in this book, please visit the Search Press website for details
of suppliers: www.searchpress.com

To see more examples of the author's work, please visit:
www.watercolour.tv

Publisher's note

All the step-by-step photographs in this book feature the author,
Matthew Palmer, demonstrating how to paint with watercolour.
No models have been used.

Dedication

This book is dedicated to Sarah and Jacob;
you're both my world.

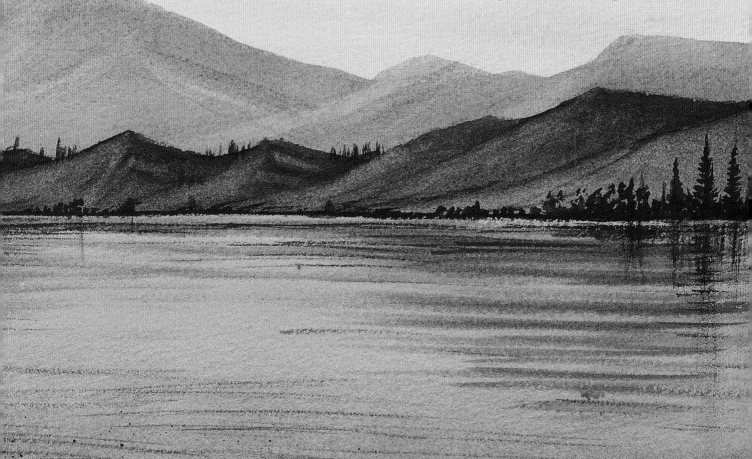

Contents

Introduction

When I began my watercolour adventure at a young age, I was baffled by the number of colours and brushes available. Where would I start? After a bit of reading and researching, I discovered that I could mix any colour from the three primary colours – blue, red and yellow.

For many years I stuck to using these three colours alone, and this is how I learned to mix colours. Even when I began teaching watercolour, I used simply these three. Reducing your palette is a great way to learn and understand colours, colour mixing and the tonal range of watercolour paints. In terms of brushes, three round-tipped brushes of different sizes are all you need: these will allow you to go from sky washes to fine details.

This book is a great place to begin your own watercolour journey – as a self-taught artist who began teaching almost twenty years ago, I have come to realise what my students need to know. It will teach you all the techniques you need, and is packed with the watercolour knowledge I've picked up over the years. I'm going back to when I began painting, and touching on the techniques I wanted to learn.

In this book, I will take you from drawing your mountain scene to colour mixing, making brushstrokes, painting skies, adding shadows, depicting trees, figures, water and, of course, mountains. All nine projects include detailed steps, and all use just three colours and three brushes.

Enjoy the watercolour journey you are about to go on – and happy painting!

Before you begin

The paper I have used for the paintings in this book has a weight of 300gsm (140lb per ream) and a Not (not-pressed) surface; Not being a medium-texture surface that is neither rough nor smooth. I recommend attaching your paper to a firm cardboard or wooden board on all four sides with masking tape that overlaps the watercolour paper slightly. This keeps the paper firm.

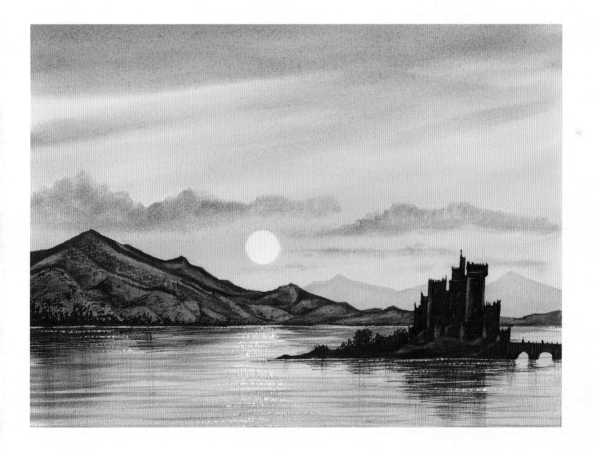

Using the colours

Using only the three primary colours – blue (French ultramarine), red (alizarin crimson) and yellow (cadmium yellow) – is a great way of working. Not only will it teach you the art of colour mixing; it is also ideal for keeping down the cost of purchasing paints. It's amazing how many colours you can mix from just three pure pigments.

These pigments are available in tube or pan format – pan format being a hard, dried paint sold in wells. I use tubes, from which I can simply squirt a blob of paint into my palette and mix in the palette with a damp brush. A little goes a long way.

People often ask me, "how come you don't use white or black paints?" and the answer is simply because watercolour is transparent and white is the white of the paper. Conversely, black is too dark for watercolour painting and grey is typically the best colour for working in shadows.

Add more water to lighten your paint; or use a strong mix with less water, and you have darker, deeper tones. Bear in mind that you do need water with watercolour. but even a brushload of water is enough to mix your paints successfully. A good tip is to test the colour on a spare sheet of paper before you apply it to your painting.

The colour wheel and mixes

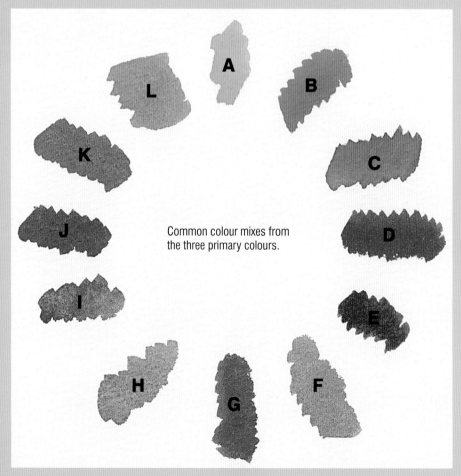

Common colour mixes from the three primary colours.

On this colour wheel, yellow (A), red (E) and blue (I) are the primary three colours; the other colours in the wheel are mixes of these three. These are known as secondary (a mix of any two colours) and tertiary colours (a mix of any three).

A Cadmium yellow

B Light orange:70% yellow, 30% red

C Dark orange: 70% red, 30% yellow

D Brown: 50% yellow, 30% red, 20% blue

E Alizarin crimson

F Pale grey (shadow colour): 60% blue, 10% red, 30% yellow, plus plenty of water to dilute

G Dark grey: 60% blue, 10% red, 30% yellow, much less water than mix **F**

H Violet: 70% blue, 30% red

I French ultramarine

J Dark green: 70% blue, 30% yellow

K Green: 50% yellow, 50% blue

L Light green: 70% yellow, 30% blue

Dilution – how much water should I add?

Depending on the area to be painted, the darkness of your colour is determined by how much water you add to your paint. Imagine water as white paint – as watercolour is transparent, the more water you add, the lighter the tone and the more the white paper will show through. This also allows paint to be painted over the top of an already dry colour, to allow shadows to be added.

The image below shows how water dilutes the paint. The strong colour on the left is almost pure paint, straight from the tube. With a damp brush, I have graduated, or moved, the paint to the right – see how it fades to a lighter tone. The watercolour paper shines through – this is why we don't need white to lighten colours, simply water.

Cleaning, rinsing, tapping or wiping the brush

This is an essential technique in watercolour painting; it is how you control the amount of water you use. Having a saturated or loaded brush will result in too much water on your paper; throughout the projects in this book you will see that I'm often 'tapping off the excess on kitchen paper'. This gives more control over mixing and painting. If you want detail from your brush, once you have picked up the paint, simply give the brush a gentle tap on kitchen paper to remove the excess moisture. This will allow for finer lines. This also applies for mixing a stronger or thicker colour: using less water makes the paint stronger.

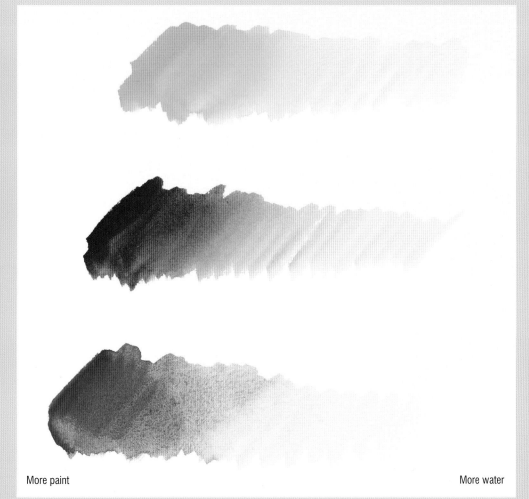

More paint More water

Swatches showing a graduation from thick to thin or dark to light watercolour using the three primary colours.

9

Using the brushes

You need only three round brushes for the projects in this book, in sizes 12, 6 and 2. Synthetic-hair brushes are fine, and are inexpensive. These will allow you to paint large skies, flowing water, the base coats of the mountains and the fine details such as distant trees and birds in the sky. Although there are different-shaped brushes available, round brushes work best as they allow a single brushstroke to taper from thick to thin.

Making brushstrokes

Here are some of the strokes you can make with the three brushes. The more pressure you apply, the broader the stroke. Round brushes have pointed tips that are ideal for applying fine detail to your paintings.

Large brush (size 12 round)

Medium brush (size 6 round)

Small brush (size 2 round)

Brush techniques

Dry-brush technique with the medium brush

This is used to create a textured effect in a watercolour, such as grassy banking, rocky mountainsides, dry-stone walls and roofs of buildings. Dry-brush is created by having less paint on your brush – tap off any excess on kitchen paper. Use the side of the brush rather than the tip to 'tickle' the brush carefully against the paper. The brush both hits and misses the grain, creating a random effect with the paint.

The dry-brush technique

Splaying the bristles of the brush

Pinching and splaying the hairs of your brush will give a greater, more broken dry-brush effect. Always wipe off excess paint with paper tissue or kitchen paper first.

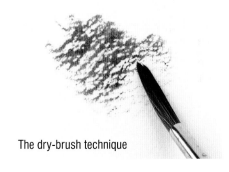

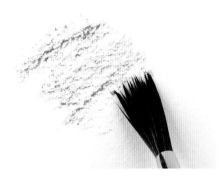

Stippling

Stippling is a great way to create realistic tree or foliage effects.

Mix a fairly strong colour in your palette and squash your brush, bristles open, into the colour in the well.

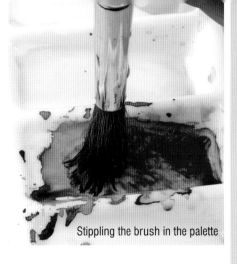

Stippling the brush in the palette

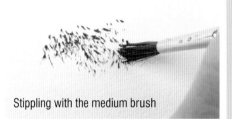

Stippling with the large brush

Stippling with the medium brush

Gentle taps against the paper with the stippled end of a large round brush will give a nice open-leaf effect.

Stippling with the medium brush will give a smaller leaf effect, or the impression of distant trees.

Splattering

Splattering is a useful technique for creating random patterns such as pebbles or flowers in the foreground of a mountain scene – a green mix splattered over the crown of a tree will give a naturalistic, open-leaf effect. Splattering against a wet background will cause the paint to bleed and make your splatters bigger.

Think 'medium' for this technique – use a medium brush loaded with a medium-strength colour. Wipe off any excess paint on your palette. Hold the brush at the bottom to keep the movement free. Hold out a finger of your non-dominant hand and tap the brush quite firmly on your finger to splatter the paint onto the paper.

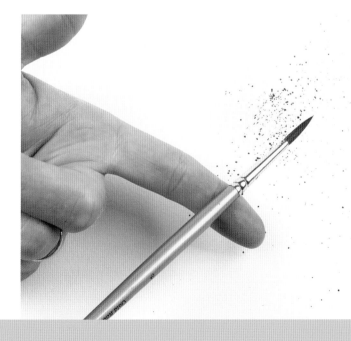

More techniques used in this book:

Making a stamp from a coin

1 Fold a sheet of kitchen paper in half, place a small coin in the centre, then grab the coin from the back of the sheet.

2 Turn over the coin and twist the kitchen paper into a stem. Make sure there are no bumps around the edges of the coin – it is now ready for you to use as a stamp, to lift out a sun or a moon.

Removing the adhesive from masking tape

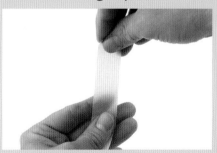

Before attaching masking tape to a painting to use as a mask, for example a horizon line or snowy mountain, remove the stickiness by running your fingers over it, or sticking it to a board or to your clothing.

Simple Mountain

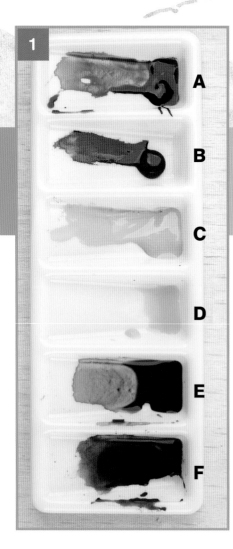

What you learn:

- **Painting a cloudy sky**
- **Lifting out highlights**
- **Stippling foliage**

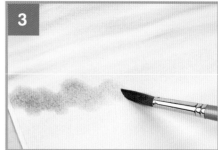

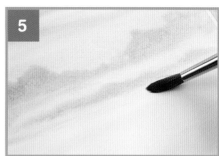

JARGON BUSTER

Twisting and softening is used to create clouds and skies. The twisting process involves twisting your wrist rather than the brush to create the effect, and works well with a wet background – that is, working wet into wet (see page 16). Softening is a way of blending away damp or wet paint to give an almost graduated effect, such as for the base of a cloud.

Once the paint has been twisted in, clean the brush, squeeze the bristles through your fingers to flatten them, then make use of the flat paddle-shaped brush to soften the base of the cloud into the paper.

1 The colours and mixes for this first project are as follows: French ultramarine (A); alizarin crimson (B); cadmium yellow (C); diluted, pale cadmium yellow (D); medium-strength French ultramarine (E); and grey (F) – 60% blue, 10% red, 30% yellow, diluted a touch with water.

2 Wet the entire sheet of paper using the large brush. Make sure there are no dry patches by lifting the board and checking that the whole paper is fully covered with water. Begin with mix D; from halfway up the paper, sweep the colour down on a slight diagonal with the large brush, to the bottom. Work in fresh paint, leaving some lighter stripes.

3 Using mix E, work down from the top of the paper, making sure you fill the whole paper. Allow the blue to mix with the yellow. Change your stroke from horizontal to **twisted** clouds (see Jargon Buster). As the blue mixes with the yellow it will go grey. If it goes green the yellow is too strong. Make smaller twists for smaller clouds. Practise creating twisted clouds on scrap paper first.

4 Squeeze the moisture out of the tip of brush with your fingers and form the bristles into a paddle shape.

5 With the flat brush, wipe the bases of the clouds to soften them. Allow to dry. Don't add any more paint or you will get **cauliflowers** (see Jargon Buster, opposite).

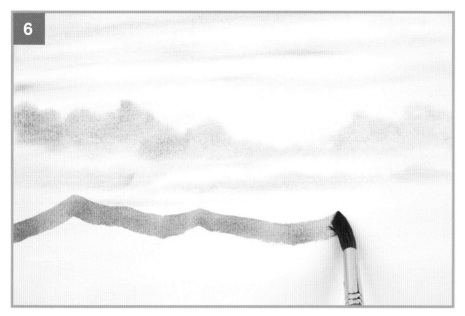

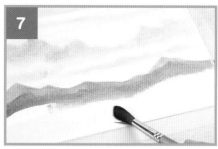

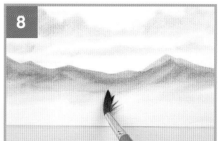

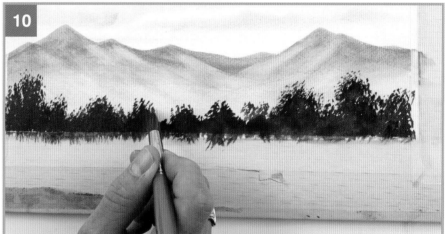

6 Add water to the grey mix (F) to dilute it. Using the grey, and working on dried paper with the large brush, paint in the distant mountains. Start on one side of the paper and make use of the point of the brush, applying a slight shake to give character to the peaks. Put as much time as you like into the shape or contour of the mountain. This goes in just below the clouds: paint halfway down towards the bottom of the page.

7 Clean your brush. Apply a puddle of water below the grey, down to the bottom of the page. Move your brush over the top of the grey and drag it down into the water to create a **graduated wash** (see Jargon Buster).

8 Clean the brush and flatten the bristles (see step 4). With the flat edge of the brush, drag down some lighter lines from the tips of the mountains. This will create highlights. Encourage with a slightly damper brush if the colour is not coming out easily. Allow to dry.

9 Mix up a thicker, stronger grey from all three colours. In the well, work a stipple action with the large brush in the paint.

10 Work across the painting to stipple in the silhouettes of tree shapes in the foreground. Make gentle taps with the brush for widespread leaves. Keep working over the tops of the trees to create solid shapes with nice open tops.

JARGON BUSTER

Cauliflowers When you apply wet paint to an almost dry area, the shape created resembles the edge of a cauliflower. This is normally classed as a mistake.

JARGON BUSTER

Graduated wash This is how most skies are painted, with darker, stronger colour at the top, gradually fading lighter – 'graduating' the paint.

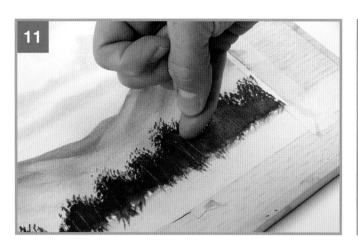

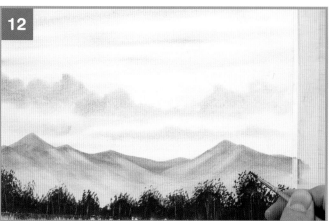

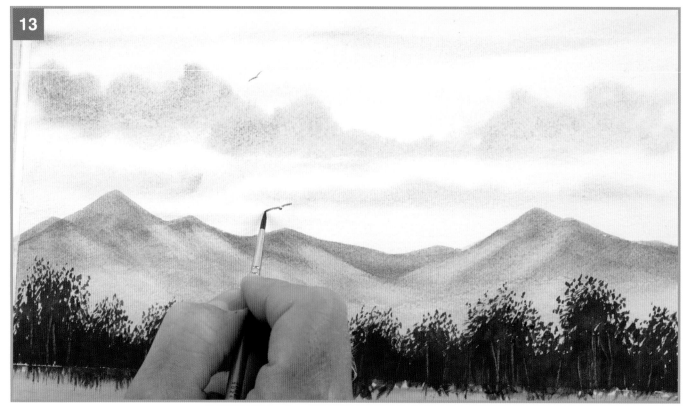

11 Use a fingernail to scratch a few lighter branches into the trees; feel free to rotate the board to a more comfortable position and scrape in the direction of growth.

12 Use the small brush with dark grey to put a few dots and spots around the tops of the trees to add more details of individual leaves and change the shape of some of the trees.

13 If you have any splatters or spots of paint in the sky, paint over them with the shapes of birds using the small brush and the dark grey (F). Leaving a gap between the wings suggests a more realistic bird.

The finished painting.
In the next project you will learn how to apply the dry-brush technique and portray a range of snow-capped mountains.

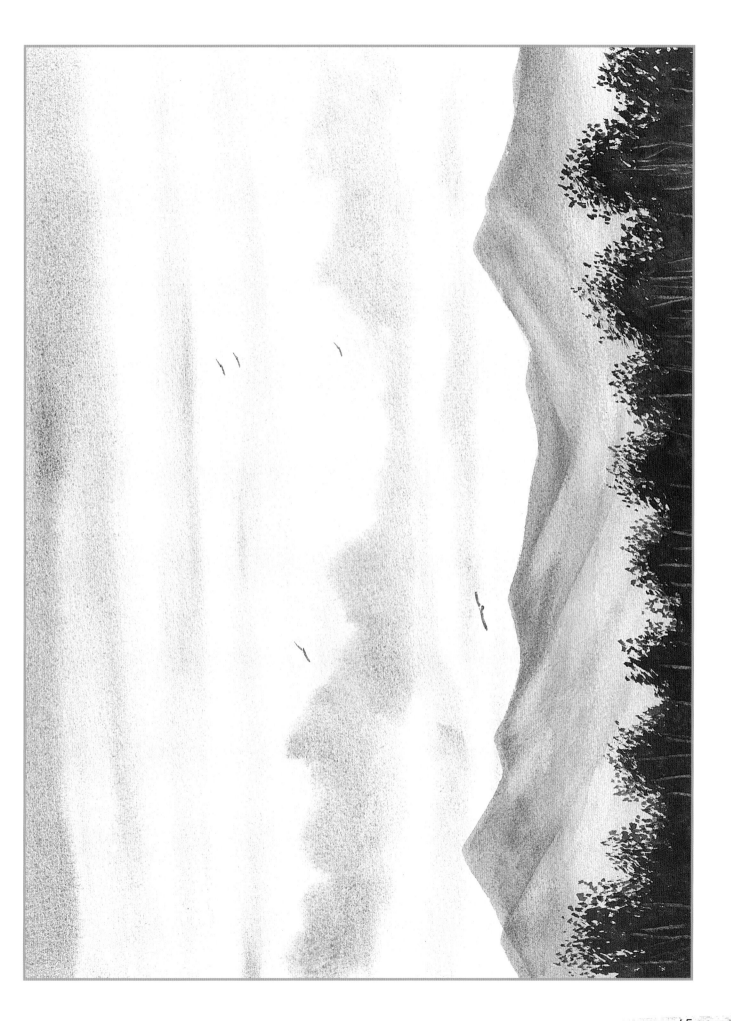

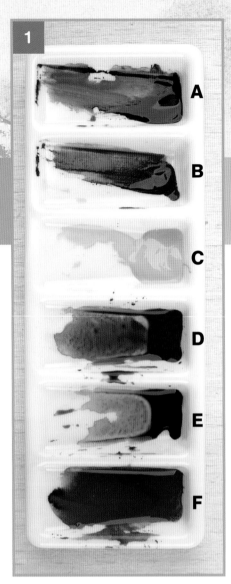

Snow-capped Mountain

What you learn:

- **Dry-brush technique**
- **Masking out areas**
- **Painting a stormy sky**
- **Creating depth in your paintings**

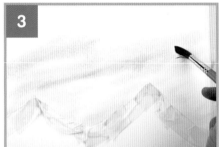

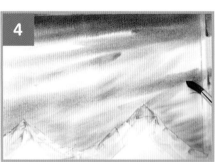

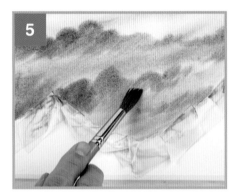

1 The colours and mixes for this project are: French ultramarine (A); alizarin crimson (B); cadmium yellow (C); strong grey (D) – 60% blue, 10% red, 30% yellow; pale violet (E) – 70% blue, 30% red; and strong brown (F) – 50% yellow, 30% red and 20% blue.

2 Create the shapes of the peaks of the mountains with masking tape, roughly applied. Remove the adhesive before you apply the tape to the paper (see page 11). Using the large brush, wet the paper from the top down to the tape. Try not to saturate the paper as you reach the tape. Sweep in pale cadmium yellow (C) diagonally about halfway down the sky area.

3 Go straight in with alizarin crimson (B) **wet into wet** (see Jargon Buster). Work slightly above the yellow with a criss-cross action so that the colours mix. Add some more red around the masking tape peaks for more contrast.

4 Without cleaning the brush, sweep the strong grey mix (D) across the very top of the paper in a criss-cross action to begin with, then start to work the grey in diagonal bands down towards the tape, ensuring you get plenty of darkness around the peaks.

5 Use the twisting and softening technique (see page 12) to add some dramatic storm clouds to the sky, using the strong grey mix (D) on the large brush. Then drag the colour down on a diagonal slant to suggest rainfall. Allow to dry.

JARGON BUSTER

Wet into wet This is the most common technique for painting skies; wetting the paper first then applying the paint allows the colours to mix and flow together.

6 Dilute the grey mix (D) and use it to put in the distant mountains. Work on dry paper and use the masking tape peaks as an edge to work against. Use the point of the large brush to give character to the ragged tops of the distant mountains.

7 Clean the brush, wipe it almost dry on paper tissue and take up a small amount of water. Soften the colour of the distant mountains down towards the taped edges. Allow to dry.

8 Carefully remove the masking tape – use a hairdryer to loosen the adhesive and prevent ripping the paper. You can expect to see a few areas of paint that have seeped under the taped area – use these to add more character to the mountains later. Use the violet mix (E) on the large brush to create separation between the two large peaks – decide which mountain is in front and which is behind (in this exercise the left-hand mountain sits in front of the right). Following the contour of the rear mountain, continue the colour down to the bottom of the paper.

9 Clean the brush, wipe off any excess water on your water pot then put a large puddle of water above the area of violet paint between the two mountains, and move the paint up into the water. Scrub as much as you need into the colour to blend it.

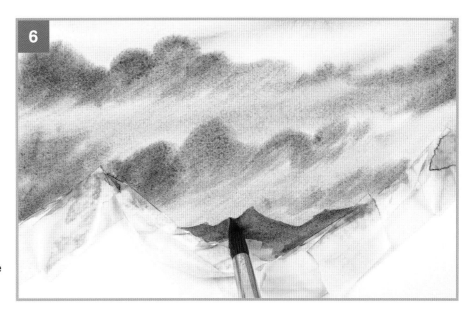

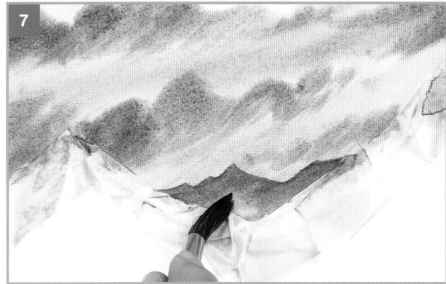

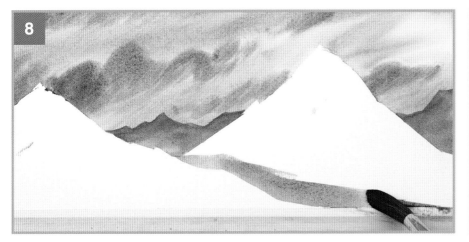

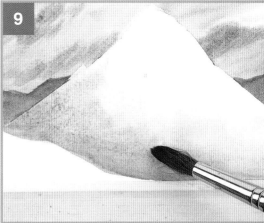

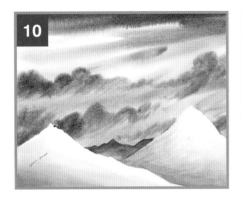

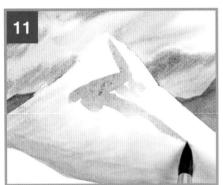

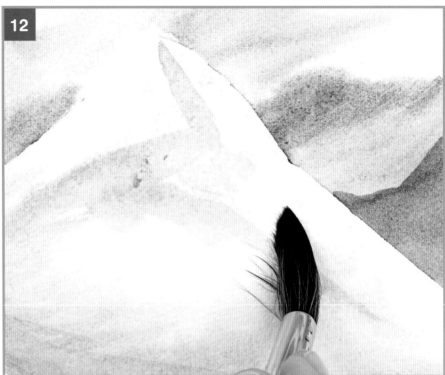

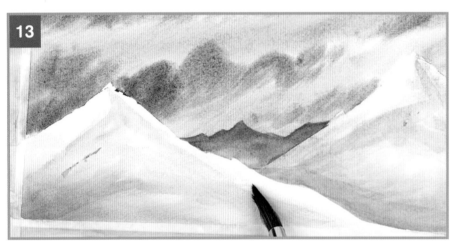

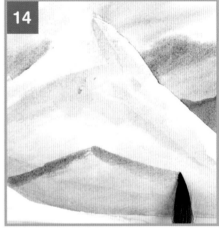

10 Repeat steps 8 and 9 in the bottom-left corner to create shadow at the base of the foremost mountain, then allow to dry.

11 Using the violet mix again (E), lay in shadows to make the mountains look three-dimensional. Paint in a zigzag that starts at the peak of the right-hand mountain and works down towards the bottom-right corner of the paper.

12 Clean and dampen your brush and quickly soften and blend the shadow into the mountain.

13 Repeat steps 11 and 12 on the left-hand mountain.

14 Go back over to the right-hand mountain and begin to add shapes into the mountain wherever you feel they should appear. Working about a third of the way up the mountain, paint in a triangular shape in the violet.

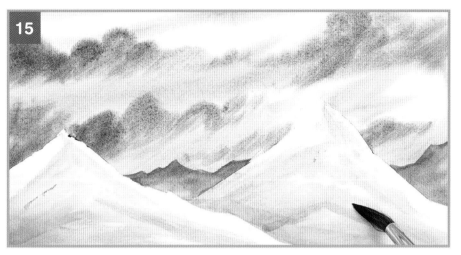

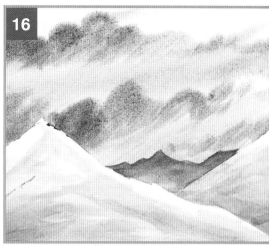

15 With a clean, damp brush, soften the colour upwards into dark shadows. These will add contours to the face of the mountain.

16 Add a similar shadow to the mountain on the left, but blend the shadows downwards. Allow to dry.

17 Switch to the medium brush. Add a tiny dot of cadmium yellow to make the colour more grey in order to add more shadows. Start with the right-hand mountain and lay in the shadows, working from the peak down the right-hand side, making the shadows wider as you move lower down.

18 Add a few lines of shadow off to the left side of the same mountain. Clean the brush, wipe off any excess on the water pot, then scrub or blend away the harsh grey line. Repeat on the left-hand mountain

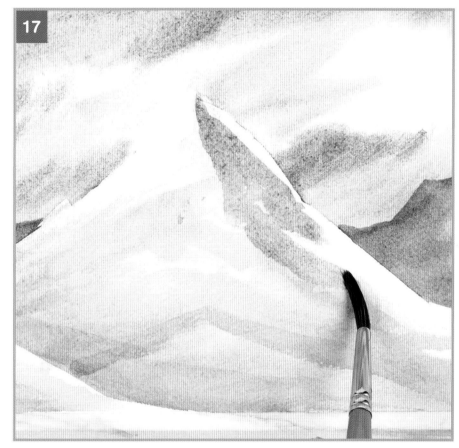

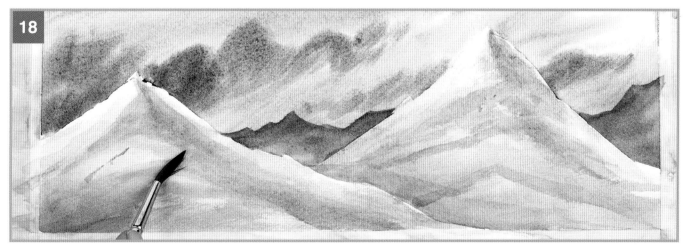

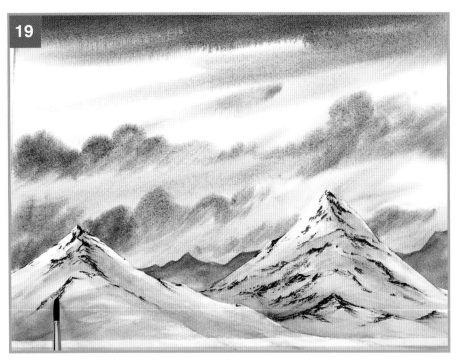

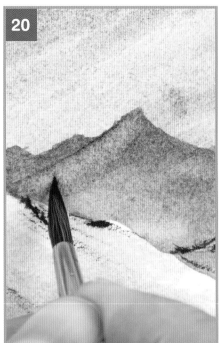

19 Using the strong brown (F) on the medium brush but keeping the brush quite dry, add some rocks poking through the snow around the mountains. Make use of the part of the brush just to the side of the tip, along with the paper texture, to put in tiny areas where the rocks are showing through. Tickle the paper with the brush to texture the rocks. Follow the contour or direction of the mountains, making use of any lines that you see that have been created by the violet shadows. Any marks created by the paint seeping through the tape earlier on can be covered with a rocky area.

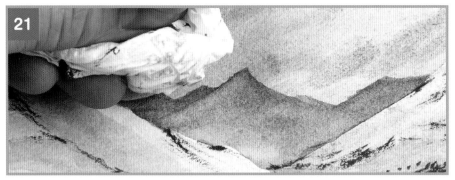

20 Clean the brush, tap it once on kitchen paper to remove any excess moisture then lift out some highlights on the left-hand sides of the faraway peaks by scrubbing with the damp brush.

21 Lift out any remaining colour with kitchen paper.

22 Finally, dilute the brown mix (F). Using a dry, medium brush, add a few tiny spots for rocks on the faraway mountains, following their contours and shapes.

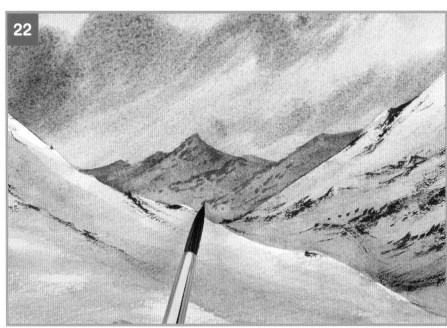

The finished painting.
In the next project you will be painting an atmospheric sunset scene featuring silhouetted figures.

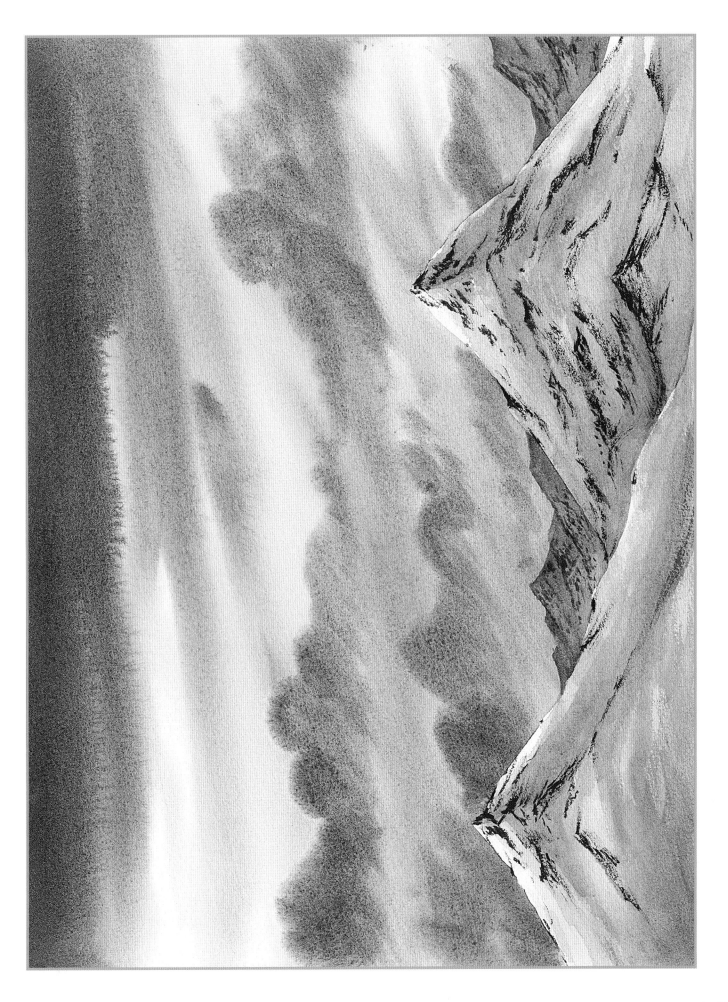

Mountain at Sunset

What you learn:

- **How to paint a sunset sky**
- **How to paint figures**
- **Scraping out highlights with a plastic card**

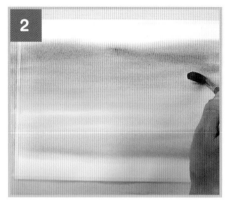

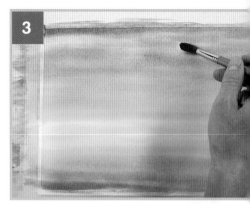

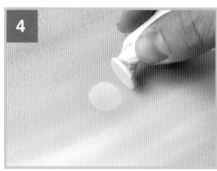

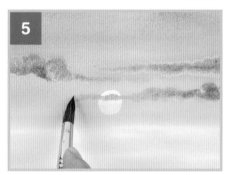

1 The colours and mixes for this project are: French ultramarine (A); alizarin crimson (B); cadmium yellow (C); light orange (D) – 70% yellow, 30% red; purple (E) – 50% blue, 50% red; strong grey (F) – 60% blue, 10% red, 30% yellow.

2 Wet the entire surface of the paper, Go straight in with a strong yellow (C) across the middle of the paper with a large brush. Lay in the light orange mix (D), wet into wet, above the yellow, working downwards with a slightly criss-cross brushstroke. Do the same below the yellow to represent the reflection of the sunset sky. Go in just above the upper orange area with pale alizarin crimson (B) but don't go all the way to the top of the paper. Again work in a criss-cross motion, down into the orange. Do the same underneath the orange area at the bottom, working up towards the orange and yellow.

3 With the purple mix (E), go across the very top of the paper and again work down in a slight criss-cross motion into the red and yellow areas. Repeat at the bottom of the paper for a reflection.

4 Wrap a small coin in kitchen paper and stamp out the setting sun (see page 11) in the area of wet paint where the orange and yellow meet.

5 Still using the large, clean brush, with no excess moisture, twist in some clouds above the sun (see page 12) using the grey mix (F). Move down to the area next to the sun and add in some darker, silhouetted clouds. Take these over the sun itself.

JARGON BUSTER

Cockling Wetting paper often causes it to 'cockle' or buckle slightly. This is normal and the paper will flatten when dry. To avoid this completely, use a heavier-weight paper like 300gsm (140lb per ream) and don't oversoak the paper with water.

Lifting out This is the removal of paint with a damp (not wet) brush. This can be done while the paint is still wet – drag the brush over the area where you require highlights. To lift out from dry paint, do the same but dab away the colour with kitchen paper.

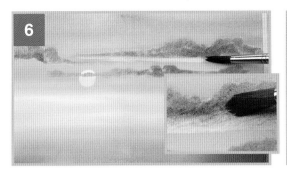

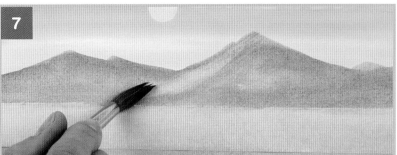

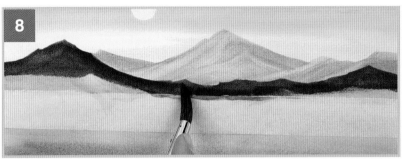

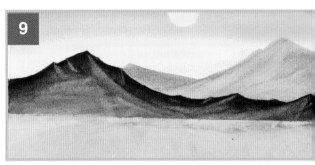

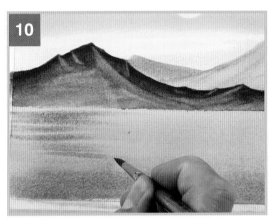

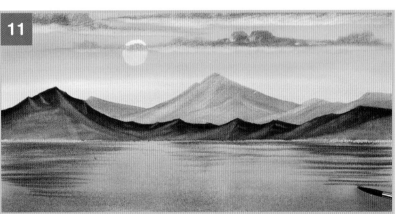

6 Clean your brush, squeeze the bristles flat to remove any excess water, then work horizontal brushstrokes at the bases of the clouds to lift out some underlit areas. Lay the brush almost flat to the paper as you do this, and squeeze out any moisture each time you repeat the process. Twist your wrist, not the brush, as you work these brushstrokes. Apply a slightly curved brushstroke in an upwards direction to soften the clouds (see inset), then allow to dry.

7 Run masking tape along the horizon. Dilute the strong grey mix (F) and use the large brush to create the mountaintops, adding a little shake here and there for character. Work the colour all the way down to the masking tape, then rinse and dry the brush before **lifting out** highlights (see Jargon Buster) on the sides of the mountains where the sun will catch. Allow to dry.

8 Work a stronger grey (F) over the original mountains to darken them and then form smaller mountains in the foreground. With a clean, damp brush, put water below the grey and drag the dark colour all the way down to the tape, making it as smooth as you can by blending. Allow to dry.

9 Use the medium brush to lift out some highlights using a single tap on kitchen paper to remove excess moisture. Add highlights where the sun hits the sides of the mountains. Rotate the board if you need to. Wipe away the highlights with kitchen paper. Put in as many highlights as you like, following the contours where the sun would be catching. Highlights change side depending on the mountains' proximity to the sun. Add tiny highlights from any peak going across the profile of the mountain.

10 Carefully remove the masking tape. If any grey paint has seeped down behind the tape it can become part of the reflection later. Now all is dry, come back to the large brush and rewet the water area. Be careful not to go too close to the mountains. Pick up the medium brush, and with the same dark grey, work in swift horizontal lines.

11 Hover slightly over the paper with the brush: the most successful ripples are painted freely in a smooth left to right action. Try to match the heights of the mountains with the reflections in the water. If possible, leave a slightly lighter area where the sun is reflected in the water. Allow to dry.

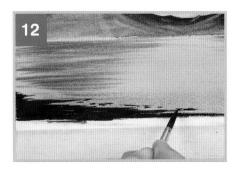

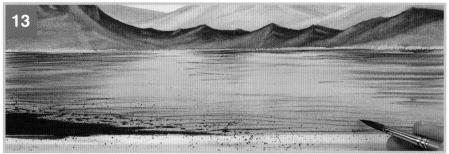

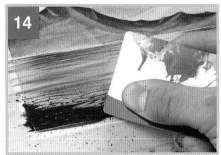

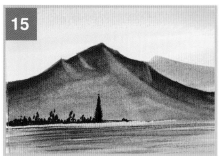

12 With dark grey on the medium brush, put in a beach made up of tapering horizontal strokes in the lower left-hand corner, working in towards the centre of the painting. Make these look like horizontal 'steps', as if the water is lapping against the shore. Add a few impressions of stones or pebbles with tiny dots leading away from the tapered ends.

13 Protect the sky area with kitchen paper then splatter (see page 11) the dark grey over the beach area to add further pebbles. Use the same grey to add a few darker ripples from the base of the mountains, leaving a gap for the sun. Put some dark ripples into the foreground, right across the picture.

14 Use a damp medium brush to '**reactivate**' the beach (see Jargon Buster), then use the corner of a plastic card to scrape out some lighter boulders.

15 With the same colour and brush, paint in a distant line of trees on the horizon. Pine or poplar trees can be painted in with straight vertical lines – paint in one side of the tree first then switch sides. Make all trees wider at the bottom and avoid placing them in the sun area.

16 Dry off the brush well and splay the bristles (see page 10). Carefully add downward reflections from the bases of the tall trees.

JARGON BUSTER

Reactivating Watercolour can be reactivated once dry, by simply painting over the area with a damp brush. Load the brush with water and tap off the excess on kitchen paper then lightly paint the required area.

17 Using a strong dark grey mix (F), add the figures on the shore by painting carrot-shaped bodies, then adding heads, leaving a small gap between head and shoulders.

18 Add more blue to mix F to make a thick, vivid grey. Add two quick flicks from the feet as shadows, bearing in mind the angle of the sun. Finally, once dry, use the small brush to lift out highlights on the right side of the figures as if they are catching the sun.

The finished painting.
In the next project you will paint a Scottish castle in
front of a mountain range.

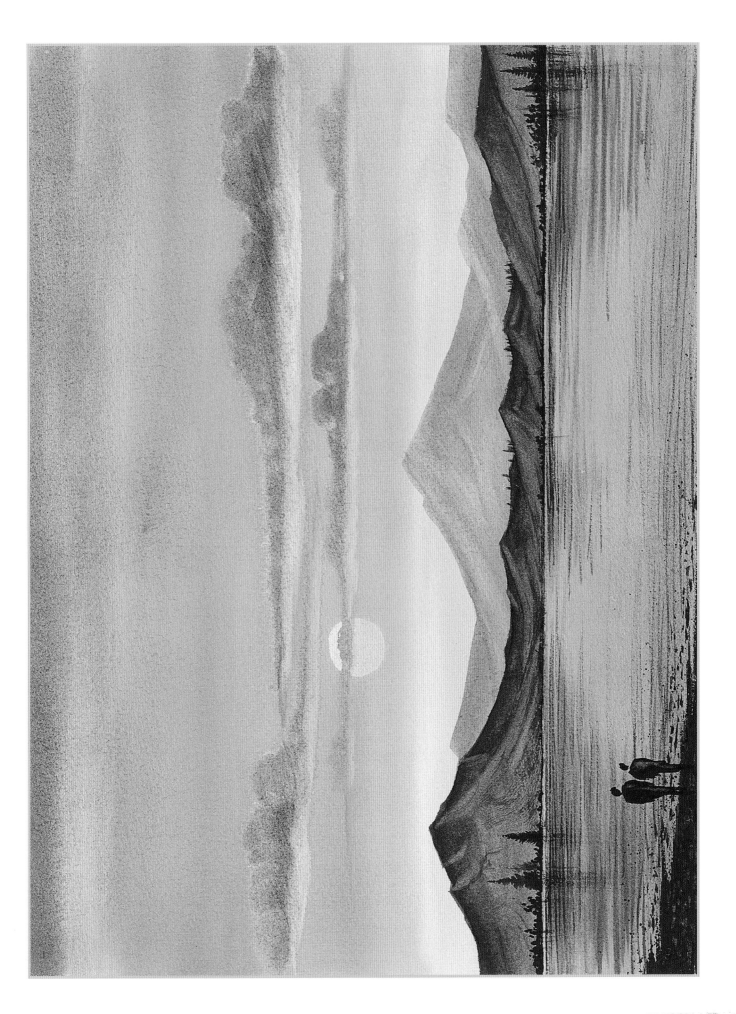

Scottish Loch

What you learn:

- **Scraping out highlights**
- **Placing reflections**
- **Painting distant trees**

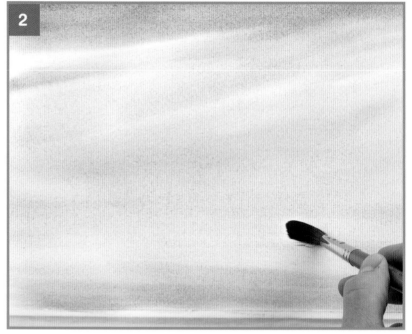

1 The colours and mixes for this project are: French ultramarine (A); pale violet (B) – 70% blue, 30% red; cadmium yellow (C); orange/pale peach (D) – 50% red, 50% yellow; strong grey (E) – 60% blue, 10% red, 30% yellow; pale grey (F) – same mix as E, but with more water.

2 Wet the whole paper with the large brush. Working wet into wet (see page 16) paint in the orange/peach mix (D) halfway up, towards the top right corner then down to the bottom of the picture. Work more angled strokes at the top of the area. With a clean brush, work the violet (B) down from the top of the paper, into the peach. Change the brushstroke direction to match the angle of the peach strokes. Repeat from the bottom of the paper until the violet meets and blends in with the peach.

3 Stamp out a sun with a wrapped coin (see page 11), then, with the violet (B) put in some twisted, softened clouds (see page 12). Put in smaller clouds underneath, making use of the fine tip of the brush. Squeeze the brush almost dry with your fingers to form a paddle shape, then soften the bottoms of the clouds. Allow the sky to dry.

4 Run a strip of masking tape across the paper, a quarter of the way up. Use the pale grey (F) to paint in the pale, distant mountains coming in from the right, all the way down to the tape, adding character as you go. Put as much time into the shape as you like; shake for character. Allow to dry.

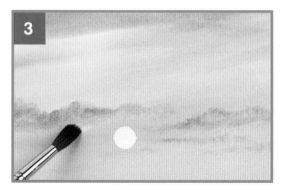

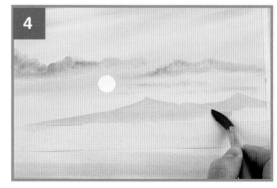

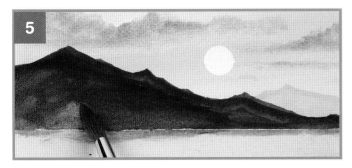

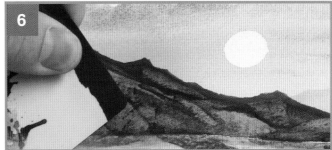

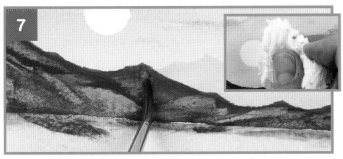

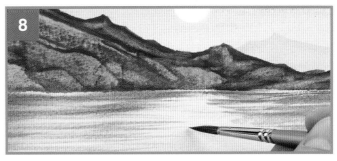

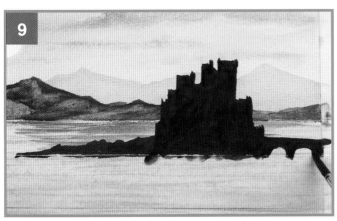

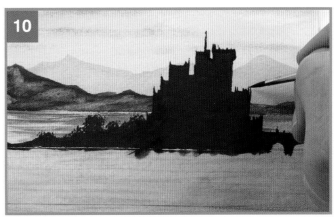

5 With the stronger grey (E), create the dark silhouette of the midground mountains coming in from the left, working slightly higher on the paper than the distant mountains. Block in the colour all the way down to the tape. While the area is still damp, take the remainder of the peach sky mix (D) and work it into the dark areas to give an added lift and reactivate the paint (see page 24).

6 Using the short, flat edge of a plastic card, remove some colour from the mountain area to create light and shade.

Tip

At step 6, if the paint dries, use a large, damp brush to glaze over the area and reactivate the colour.

7 Tidy up the mountains by lifting out highlights with the clean medium brush. Soften around the sun to give it more glow, then dab it with clean kitchen paper.

8 Remove the masking tape. Rewet the water area with the large brush, then lay in horizontal reflections of the midground mountains with the medium brush and grey mix (E). With a fairly dry brush, add a few peach (D) reflections as well.

9 Attach a horizontal strip of tape between the bottom of the paper and the base of the mountains. Using mix E on the medium brush, paint in a rocky outcrop for the castle to 'sit' on, starting halfway into the picture towards the middle of the water area. Paint long vertical strokes for the silhouette of the castle, keeping the colour strong to stand out in front of the mountains. Once you have blocked in the castle, create the bridge – a horizontal line with arches underneath leading off the paper.

10 Stipple the medium brush in the palette (see page 11) to suggest silhouetted trees on the left of the castle. Gentle taps with the tip of the brush will give an open-leaf effect. With the small brush and the dark grey mix, put in some tiny details on the castle such as a flagpole and turrets. Remove the tape carefully and allow the castle to dry.

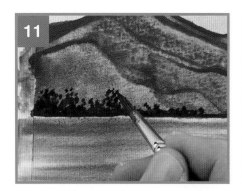

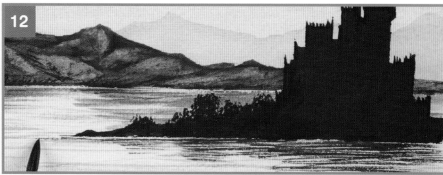

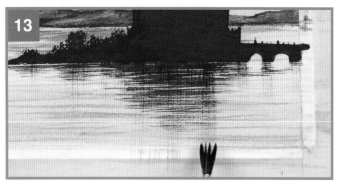

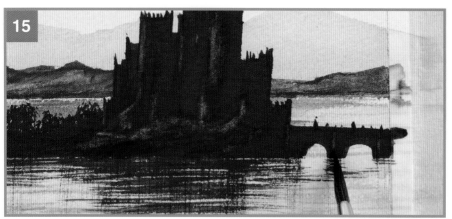

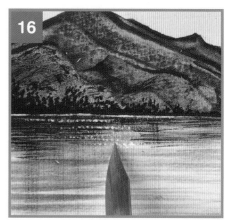

11 With the dark grey mix (E) on the medium brush, paint a horizontal line across the water's edge as far as the sun, then taper it off. Tap in little spots along the top of the line for distant trees.

12 Paint horizontal lines into the water to reflect the trees, then move across to reflect the castle into the water with a slightly diluted grey mix (F). Use horizontal brushstrokes to create ripples – at the tip of the outcrop put in an extended ripple to the left with a dry-brush stroke.

13 Splay the bristles (see page 10) and paint downward reflections along the water's edge and below the castle. Pick out some of the taller details such as turrets to give more depth. Make the reflections of the turrets parallel. Allow the reflections to dry.

14 Lift out vertical highlights from the castle area starting with the turrets – apply the damp brush first then dab the area with tissue to remove the colour.

15 At the base of the castle lift out a rocky area. Add highlights on the bridge, between the archways, then lift out tiny windows from the towers. Allow to dry.

16 Finally, with a sharp-tipped knife (a kitchen knife or craft knife) add shimmer into the water to reflect the sunlight. Cut into the paper in horizontal lines, working down from the base of the mountains and making the lines wider as you move towards the bottom of the paper. Scrape a horizontal line on the water's edge beneath the castle to give a clear separation between water and land.

The finished painting.
For the next project, you will be painting a classic scene of Alpine mountains.

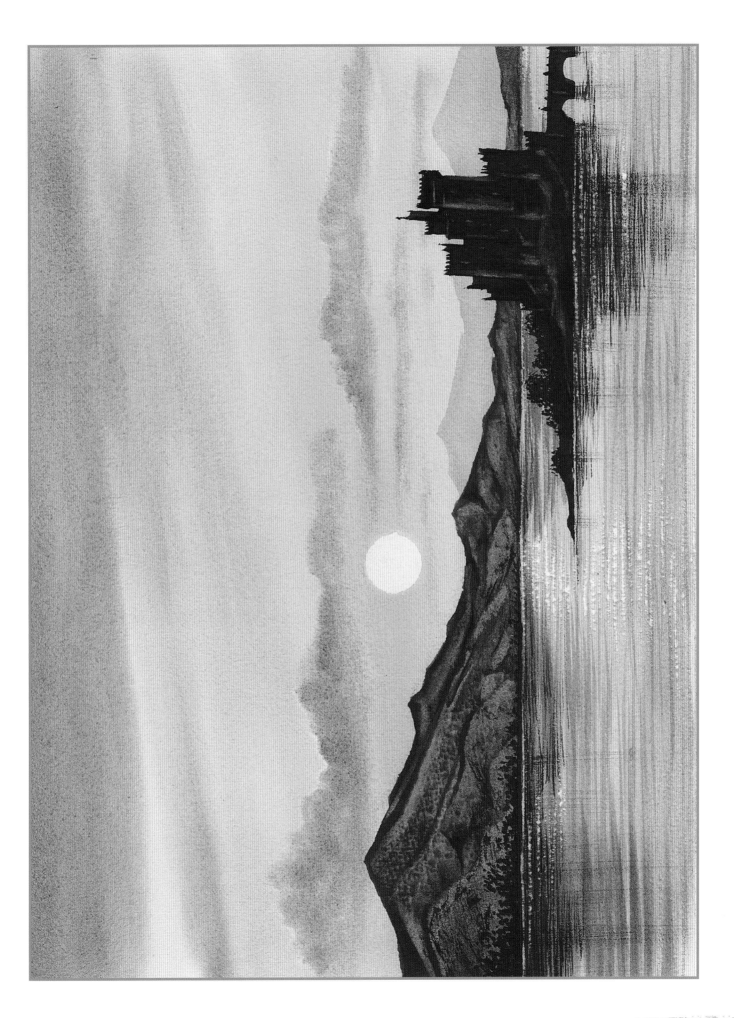

Alpine Scene

What you learn:

- **Creating distance with strong shadows**
- **Painting pine trees**
- **Painting a three-dimensional building**

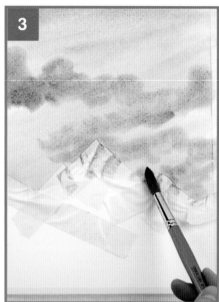

1 The colours and mixes for this project are: French ultramarine (A) – medium strength; alizarin crimson (B); cadmium yellow (C); sandstone (D) – 80% yellow, 10% red, 10% blue; pale grey (E) – 60% blue, 10% red, 30% yellow; and thick grey (F) – same mix as E but with more paint, less water.

2 Create the alpine shapes with masking tape – use small, creased strips to create the pointed ridges (the 'arêtes'). Working wet into wet, lay in the graduated sky beginning with sandstone (D), applied at an upward angle then down towards the tape. With a clean brush, lay in medium-strength blue (A) from the top left corner of the paper downwards, filling the paper with a slight criss-cross brushstroke. Mix the blue with the sandstone to form a grey and take the colour behind the mountains.

3 Twist in some clouds in pale grey (E), bringing them down towards the taped peaks. Soften the bottoms of the clouds on a diagonal, with flattened, paddle-shaped bristles. Allow to dry.

4 Remove the masking tape, using a hairdryer to heat the adhesive so that you peel off the tape without ripping the paper surface. In pencil, draw in the track as two C-shapes running from the base of the mountain. Draw the barn 'sitting' on a horizon line coming in from the left, and a hilly bank coming from the right-hand side of the paper.

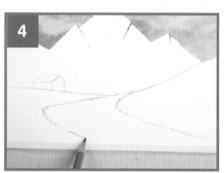

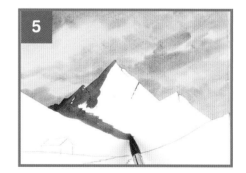

5 With the large brush and grey mix F, put in a strong shadow on the left of the central mountain in a jagged line. Bring the colour down towards the pencil lines, to form a separation with the mountain on the left – almost in an L shape.

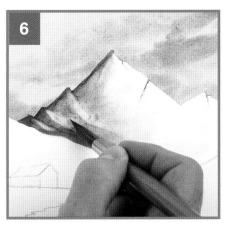

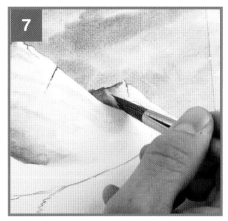

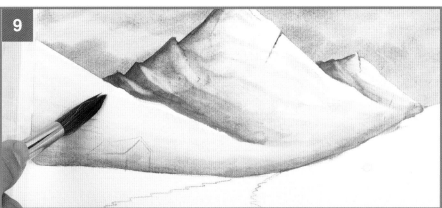

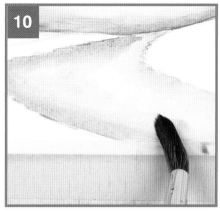

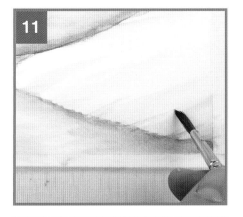

6 Clean the brush, put a puddle of water on the right of the shadow and move the brush into the grey area to smooth it across to the right, to achieve a graduated wash effect. Flatten the bristles and lift out some light lines from the shadow areas. Pull the light areas up, down and to the right to suggest contours.

7 Repeat steps 5 and 6 on the peak to the right of the central mountain.

8 Mix a new colour: grey-violet (G) consisting of 60% blue, 20% red and 20% yellow.

9 Run mix G above the pencil line on which the barn sits; take the colour across the paper from left to right, to the top of the hill on the right. With a clean brush, put a puddle of water above the grey-violet line and blend the colour into the background.

10 Drag out a few areas of pale grey-violet across the snowy ground on both sides of the track to create a cast-shadow effect. Allow the ground areas to dry.

11 Mix a new, pale violet (H) from 80% blue, 20% red. With the large brush, create the contour of the track in the foreground. Drag a few lines of violet up the hill on the right. Repeat on the left of the path – paint in a triangular shape then blend away the colour to create a vignette. Allow to dry.

Tip

The violet mix may stain your paper, so you need to work quickly when you apply it to your paper and then blend it away with the wet brush.

12 Use the grey-violet mix (G) and the medium brush to add some extra contours to the large central mountains.

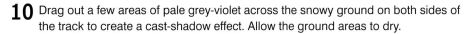

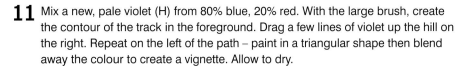

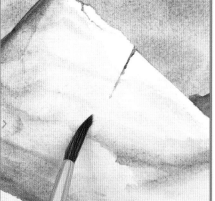

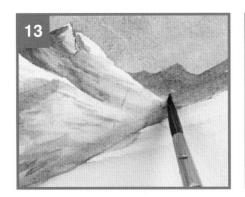

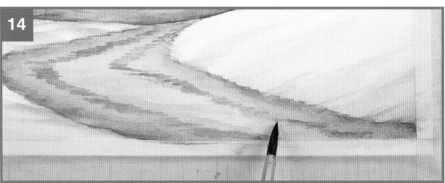

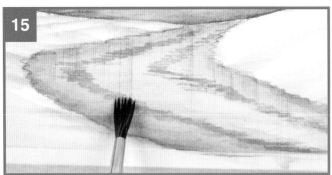

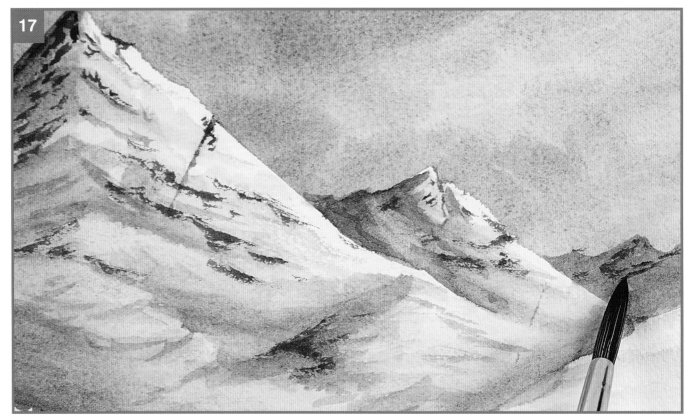

13 With pale-violet mix H and a fairly dry medium brush, add a distant mountain on the right-hand side of the scene as a solid colour. This will help to give a sense of depth. Allow to dry.

14 Use the same brush and mix to paint tyre marks on the track as short horizontal lines that follow the angle of the road and are larger in the foreground.

15 Splay the bristles and add downward reflections on the track to make it look like an icy, frozen road.

16 Mix a brown (I) from 50% yellow, 30% red and 20% blue.

17 Apply a strong-to-medium mix I with a dry medium brush to suggest stones and rocky outcrops on the mountains.

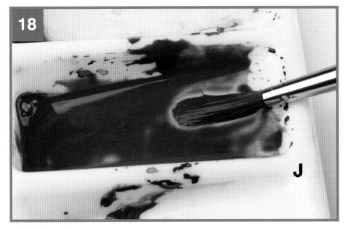

18 Mix a dark green (J) from 70% blue and 30% yellow – this is the perfect shade for pine trees.

19 Paint in some pine trees alongside the barn and behind the path on the right, using the small brush. For closer, larger trees, begin with a vertical line then paint the branches on one side from the bottom, pointing upwards. Make the lines smaller as you reach the top. Repeat on the other side of the trunk.

20 Paint in some smaller (distant) trees, in a lighter version of mix J, growing up the mountain in to the distance. Add a few tiny spots of green in the foreground for foliage.

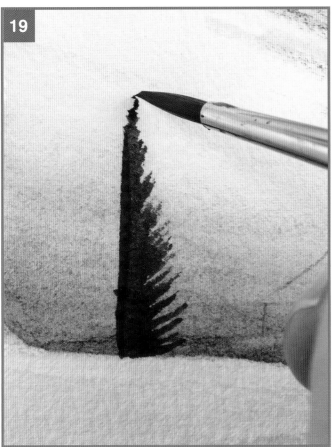

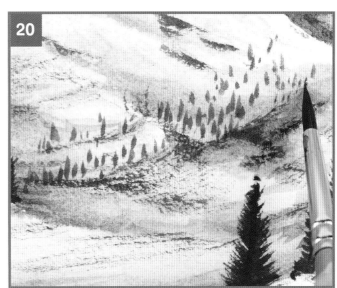

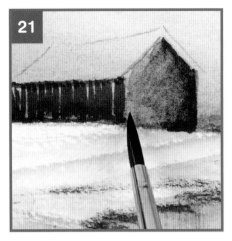

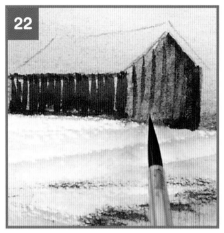

K

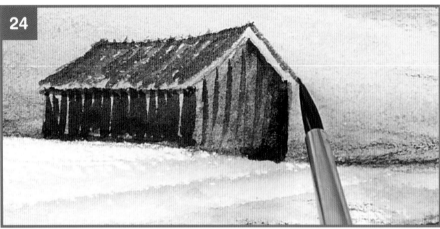

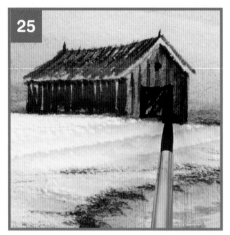

21 Come back to the original dark grey (F) on the small brush; paint in the darker – left – side of the barn in a series of vertical lines to look like wood. Paint a line across the underneath of the roof as a shadow. On the front of the barn, paint up to the point of the apex then down the right, filling in the colour to about halfway in. Use clean water to drag the grey across towards the left to lighten the 'face'. Allow the barn to dry.

22 Add a few vertical lines over the top of the 'face' of the barn.

23 Mix an orange brown (K) from 50% red, 40% yellow and 10% blue for the roof.

24 With the small brush, paint in a series of diagonal lines following the contour of the roof. Paint a thin line across the top and down the opposite side of the apex.

25 To finish, put in some dark grey dry-brush lines coming down onto the roof to give it some character. Put a couple of spikes on the top of the roof. Paint a doorway on the front face of the barn as a grey rectangle, and a window above in the form of a grey dot.

The finished painting.
Next, you will be painting a
pastoral scene of green meadows,
hills and distant mountains.

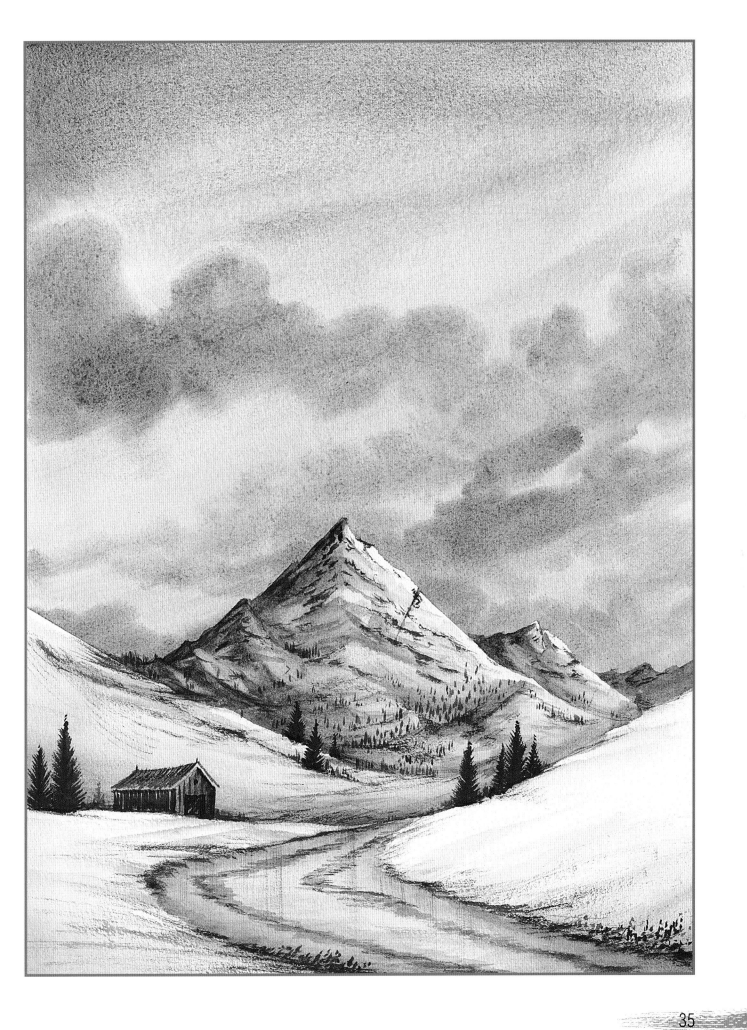

Across the Meadow

What you learn:

- **Masking with card or paper**
- **Adding highlights**
- **Painting foreground details and flowers**

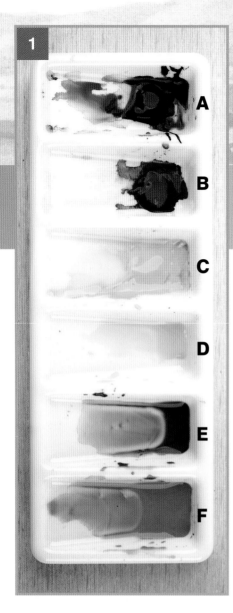

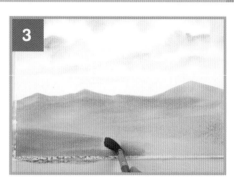

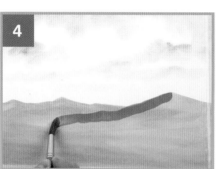

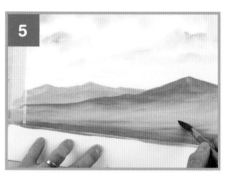

1 The colours and mixes for this project are: French ultramarine (A); alizarin crimson (B); cadmium yellow (C); diluted, pale cadmium yellow (D); grey-blue (E) – a mix of pale French ultramarine and cadmium yellow, more blue than yellow; and vivid green (F) – this is the same mix as E but with significantly more yellow, added first.

2 Wet the top half of the paper for a wet-into-wet graduated wash sky. Use the very pale yellow (D) with the large brush to paint the bottom of the sky. With a cleaned brush, apply the pure blue (A) in a twisting formation for clouds. Lay the brush against the paper and rotate the tip very quickly. Move down towards the yellow, still rotating the brush – make smaller twists as you move lower down, for smaller clouds. Allow to dry.

3 Load a pale mix of blue and yellow (E) on the large brush. Use the tip of the brush below the clouds to put in the shapes of the mountains. Clean the brush, wipe off any excess then add a stronger mix of blue and yellow, working down to the foreground. Add a touch more yellow to the mix this time to lift the foreground further, and smooth the colour with strong, bold back-and-forth strokes. Allow to dry.

4 Lift the midground mountain forward; add a touch more blue to the green mix (F) on the large brush. The colour should still be fairly strong: a 60:40 ratio, yellow to blue. Paint over the right-hand mountain; bring down the colour and imagine you are creating a recession in the distance. Bring this down by 5cm (2in). Clean the brush and shake off any excess moisture then use the damp brush to blend the colour down into the foreground; make sure the blend is smooth, then allow to dry.

5 Use scrap card to mask off the foreground area. Create a hill; use mix F to paint across the masked line. Work the colour up about 2.5cm (1in). With a clean brush, blend the mix upwards using back-and-forth brushstrokes so the green disappears up towards the background.

6 Add highlights to the midground mountain, following the contours, in a scrubbing motion with the medium brush then use kitchen paper to dab off the colour.

7 Add highlights to the misty hills in the background on the left in the same way, using the same brush.

8 Add light to the base of the foreground hill to soften and wash away the edge. Dab away the colour, then allow to dry.

9 Using the card as a mask again, paint in some midground hedgerows and field boundaries with the medium brush and mix E. Start roughly halfway up the paper, at the foot of the right-hand mountain. Give the hedgerows some character and height by putting spots along the top edges with the tip of the brush. Leave a gap for a gate in the middle of the central hedgerow.

10 Changing the angle of the card, put in some diagonal hedgerows towards the foreground. Add in dots here and there for distant bushes and trees.

Tip

Think about perspective – make the bushes larger as you move down, and thinner as they move into the distance.

11 Still using the medium brush, add a few distant pines or poplars (see page 33). Sit the pines or poplars on top of the distant hedgerows, and add larger trees lower down.

12 Add a few small trees riding up the side of the mountain. Then, with the small brush, put in a few diagonal highlights on the poplars and pines, using the lifting out technique (see page 22) to take away the harsh darkness of the trees.

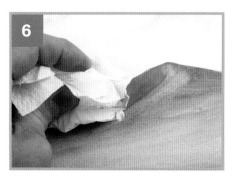

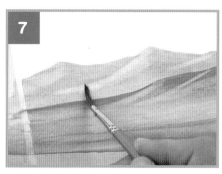

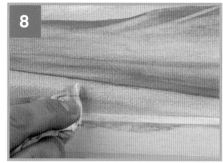

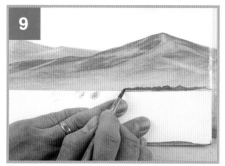

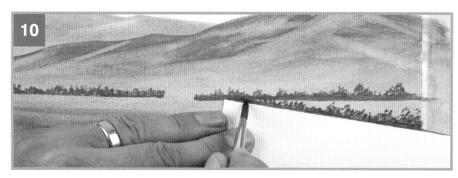

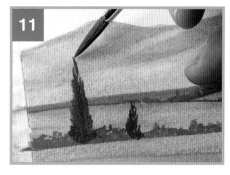

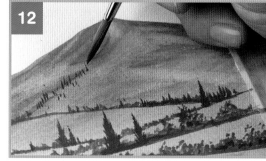

13 Use the medium brush with a pale (dilute) mix of E – apply a dry-brush technique (see page 10) using the side of the bristle tip to add a few diagonal cast shadows coming away from the bases of the hedgerows, to the right.

14 With a pencil, draw in a foreground gate and fenceposts.

Tip

The gate and fenceposts can be painted straight onto the scene, but sketching will give you more control.

15 Make up a dark brown mix (G) from 40% yellow, 20% red and 40% blue.

16 Use the small brush with mix G to paint in the fenceposts and the gate. Put in a few little spots and dots to represent details. With a clean brush, gently lighten the left-hand sides of the large posts next to the gate to round them. Soften any harsh edges. Dilute mix G and use the colour to paint in a wire running across the top of the posts, wobbling your brush a little to give the wire some detail to represent barbed wire: add dots every so often to add character to the wire.

17 With a fresh, pale mix E, lay in shadows from the bases of the gate and fenceposts, running in the same direction as the shadows from the hedgerows.

18 Load the small brush with a strong mix F to add some grasses and foliage growing around the fence and across the edge of the hillside. These work best as tiny spots. Add in a touch of dry brush at the bases of the fenceposts.

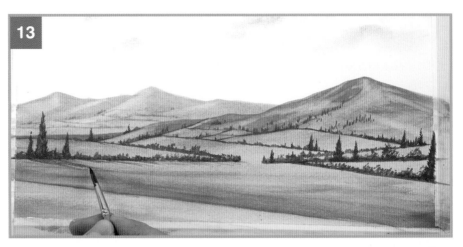

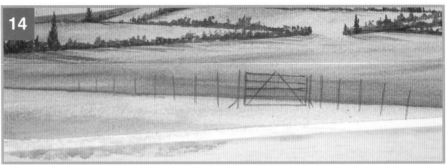

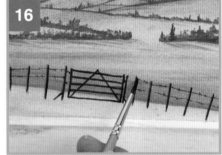

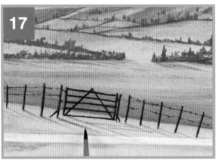

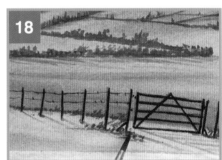

19 Use the same green to give the impression of a distant path leading from the gap in the midground field to the foreground. The angle of the path is important so sketch it in first if you prefer. 'Tickle' the dry brush against the paper, making use of the watercolour surface. Continue the path into the field behind the fence if you need to – the weaving path should look like a giant letter S, and will create a sense of distance.

20 Add a few foreground flowers using a small brush and a thick consistency of cadmium yellow (C) to start with, then dot in some red flowers in dilute alizarin crimson (B). Place the flowers around the base of the gate and around some of the fenceposts.

21 Still with the small brush, make use of the colours remaining in your palette. Use the brown mix (G) to paint in a small, distant gate in the gap in the hedgerow. Put a few little dots at the base of the lower hedgerows for more shadow. This will lift the area forward, thus creating more of a sense of depth.

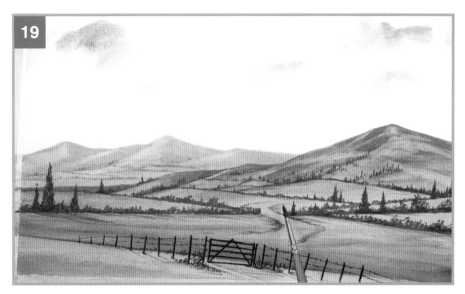

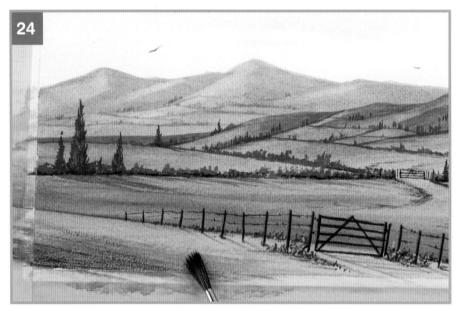

22 Use brown (mix G) on the small brush to add some birds in the sky, and cover up any inadvertent paint splatters. Remember to leave a gap between the wings to suggest light.

23 Remove most of the colour from the medium brush and pinch the bristles with your fingers to splay them.

24 Finally, in the bottom-left corner of the painting, where the scene goes off the edge of the paper, lay in weak dry-brush strokes with the green mix (F), barely touching the paper with the bristles.

The finished painting.
The next project has a distinctly autumnal feel – you will be depicting a scene from the Lake District, UK, in glorious autumn colours.

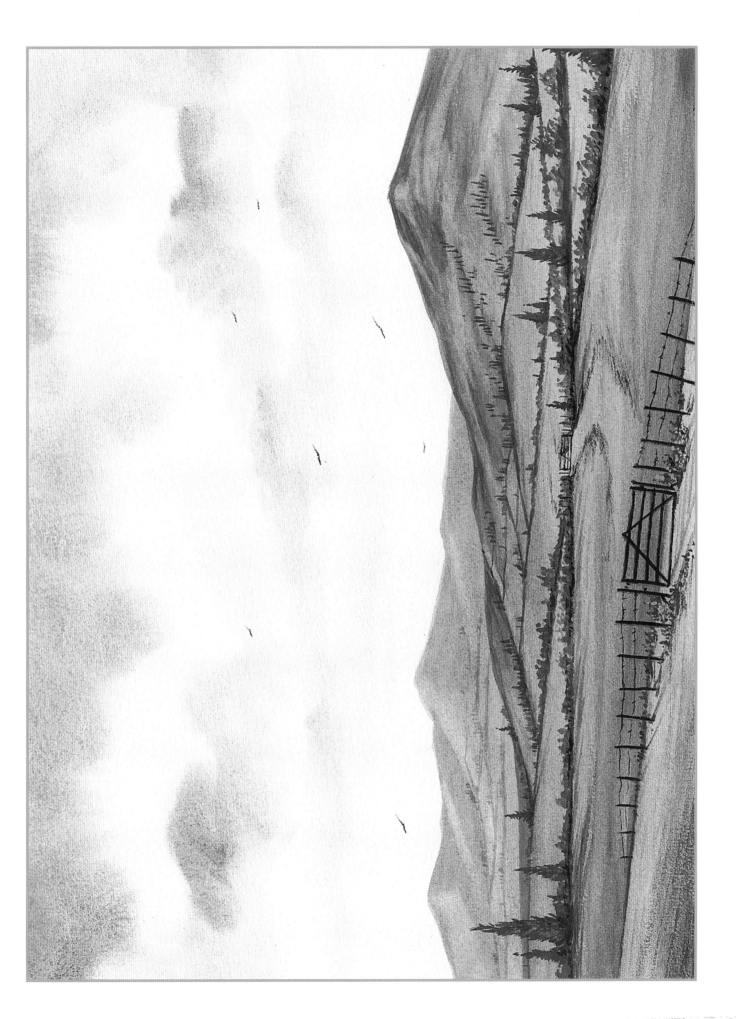

Lake District

What you learn:

- **Painting large trees and woodlands**
- **Creating rocks**
- **Scraping out tree trunks and branches**

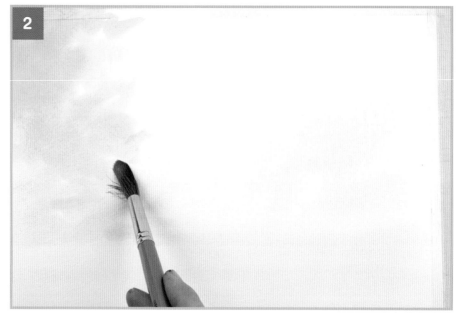

1 The colours and mixes for this project are: French ultramarine (A) – medium to pale; alizarin crimson (B); cadmium yellow (C) – pale; light orange (D) – 70% yellow, 30% red; orange-brown (E) – 70% yellow, 20% red, 10% blue; and brown-grey (F) – 50% blue, 30% red and 20% yellow.

2 With the large brush, wet the paper from top to bottom. Apply the pale yellow (C) in a twisting motion in the centre of the sky then paint in horizontal strokes below to reflect the colour in the water. Use a stronger version of the yellow to twist foliage in where the autumnal trees will be.

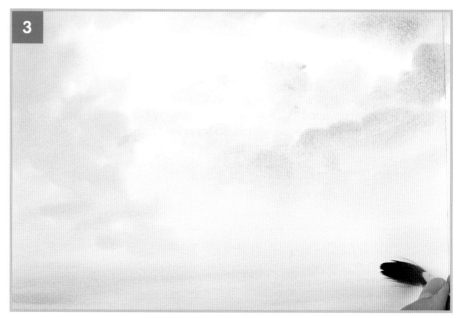

3 Load the brush with medium-strength blue (A) and twist in some clouds. Don't be afraid to bring the blue over the yellow to make green – this will help build up the trees later on. Lay horizontal blue strokes across the foreground to represent water but again allow the blue to blend into the yellow.

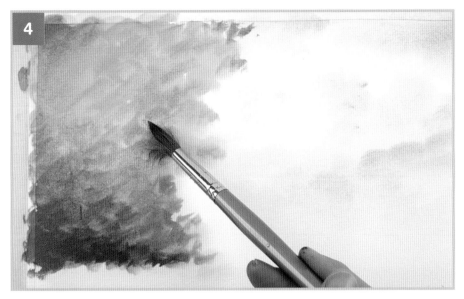

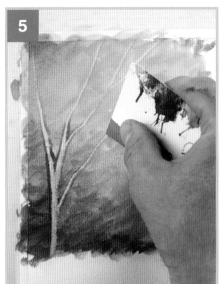

G

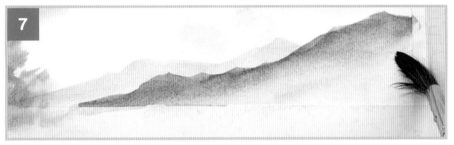

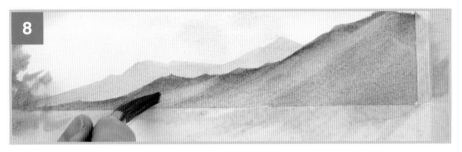

4 With a clean, damp – drip-free – brush, introduce light orange (D) into the foliage. Go straight into the orange-brown (E) without cleaning your brush; twist in the colour from the bottom upwards. Spend time adding little individual twists around the edges. Again without cleaning your brush, place brown-grey (mix F) at the bottom of the foliage area. Twist the colour across the base of the trees then work the colour upwards. With a clean, almost dry brush, twist over the top of the dark colour to blend it in to the mass of foliage.

5 Reactivate the paint if you need to, with a clean, damp brush that is not too wet. Then use the corner of a plastic card to scrape out some birch trunks from the bottom of the foliage mass to the top. Apply pressure at the bottom then ease off as you move upwards. These trunks will go light or dark depending on how wet or damp the foliage is. The drier the foliage, the lighter the trunks will be. Allow the area to dry.

6 Mix a pale grey (G) from 60% blue, 10% red and 30% yellow.

7 Place a strip of masking tape just above the bottom edge of the treeline. Paint in some distant mountains with mix G from behind the foliage, then use a damp brush to lighten the area down towards the masking tape edge. Allow to dry then make a darker grey mix from G (more paint, less water) and paint over the original, pale mountains. Again, soften down the colour to create recession.

8 While the foreground mountain area is still damp, pick up some of the orange mix (D) and add this, wet into wet, at the base of the mountain, working into the grey. Squeeze the brush into a paddle shape, then drag down the left edge of the mountain area and lift out the highlights.

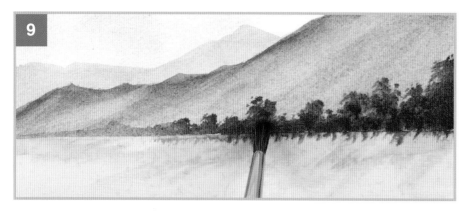

9 Stipple the medium brush into the palette well containing mix E, to separate the bristles. Stipple a line of trees along the top of the tape – larger trees to the right, smaller to the left. With a clean, almost dry brush, twist and blend away the trees to the left to add depth. Take up the brown-grey mix (F) and stipple along the base of the trees to add shadow. Move from right to left and make the colour paler as you go. Once the paint is dry, remove the tape – use a hairdryer to help soften the remaining adhesive.

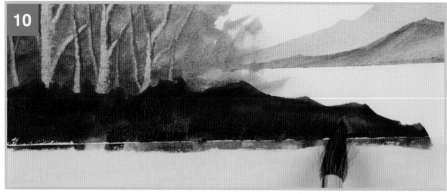

10 Apply another strip of tape just below the trees to form a base for the foreground rocks. With the large brush, mix a thick, dark grey (H) from 60% blue, 10% red and 30% yellow. Paint the top edge of the rocky base in a similar way to the mountains. Without cleaning your brush, fill in the rocky base in brown-grey (mix F), working over the grey top outline. Leave a few lighter patches, and fill these with the lighter orange mix (D). Scrub all the colours together, then reactivate the paint if you need to.

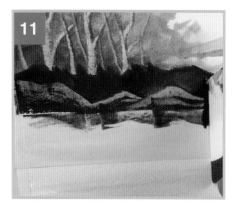 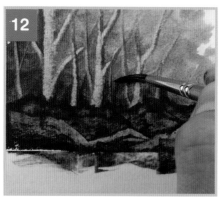

11 Scrape out the details of the rocks with the corner of the plastic card.

12 Soften the hard, grey top edge of the rocks with the medium brush – drag the colour up in between the trees.

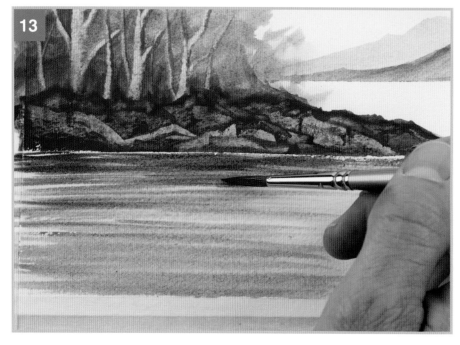

13 With the large brush and clean water, rewet the area below the rocks and across the foreground. Then with the tip of the medium brush and the brown-grey mix (F), paint horizontal lines to reflect the rock area. Clean your brush, pick up the orange mix (D) and put in horizontal reflection lines towards the bottom of the area to reflect the trees. Finally at this stage, switch to the dark grey (H, from step 10) to put in some darker ripples on the water line. Allow the area to dry.

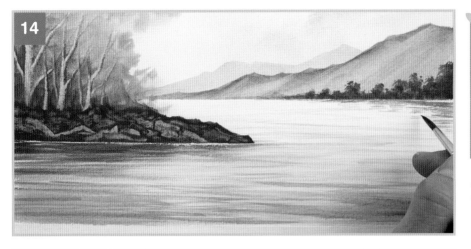

JARGON BUSTER

Wet into dry This is the opposite technique to 'wet into wet' – it is simply the practice of applying wet paint on dry paper.

14 Working **wet into dry** (see Jargon Buster) use the medium brush with diluted pale blue (A) to paint pale horizontal ripples onto the foreground water area. Work quickly, and move towards the background to give a sense of distance – make the ripple lines thinner the further you move back. Use pale grey (G) for ripples across the front of the painting and for the reflection of the tree. Using the orange-brown (E) on a slightly dry brush, add a few ripples to the base of the distant trees, mirroring their heights.

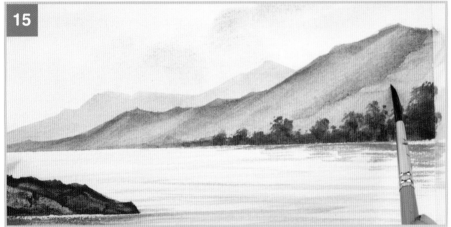

15 Use pale grey (G) to add shadows into the distant mountains to separate them – work from the top down, following the angle of each mountain, and make the shadows a little jagged. Use a clean, damp brush to soften the shadow lines down to the left then to the right for texture.

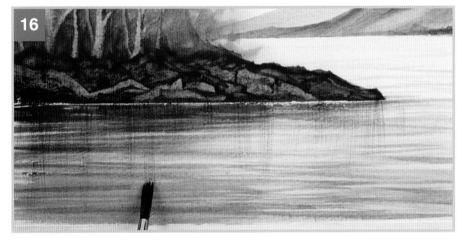

16 With the dark grey mix (H) on a dry medium brush, bristles splayed (see page 10), lay in downward reflections in the water. With the same colour on the brush, darken the edges of the rocks closest to the water. Allow the area to dry.

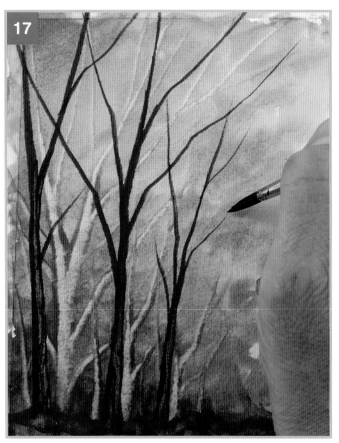

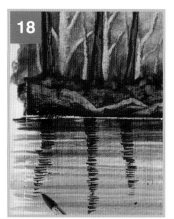

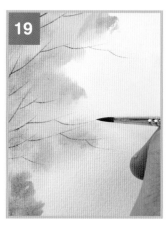

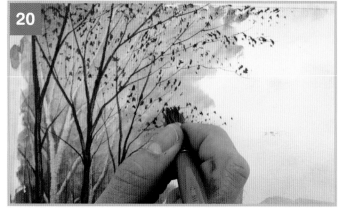

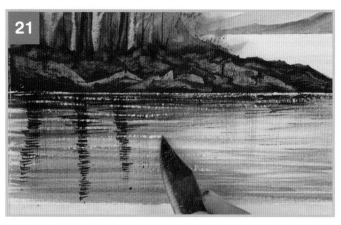

17 Paint in some dark trees using the brown-grey mix (F) at a fairly strong consistency. Paint the first tall tree up from the rocks – start wide at the base then make it thinner; paint in the direction of growth, over the top of the foliage. Gradually lift the brush off the paper as you work upwards. Once you have put in the first, most central trunk, use the corner of the plastic card to scrape out areas of light from the trunk. Taper some branches up into the crowns of the trees. Paint a second tree to the right of the first; this could be thinner; again use the plastic card to add some highlights to the trunk. The final large tree goes on the far left of the picture – almost off the edge of the paper.

18 Still using the medium brush, put in the reflections of the trees in the water with horizontal flicks of the brush, making sure the reflections line up with the trees themselves. The drier the brush, the better.

19 Change to the small brush but keep with the brown-grey mix (F). Add small, fine branches coming from the tips of the larger branches, and taper them away at the end. Clean the small brush, tap off any excess water, then use the tip to lift out a few highlights from the larger branches. Paint over the branches with the damp brush and dab off with kitchen paper.

20 Stipple the large brush in the orange-brown mix (E) in the palette, then onto the paper to suggest individual overhanging leaves. Rotate your brush to give variation between the shapes. Dilute the colour slightly and stipple in a few lighter leaves further down, into the mass of the trees. Dilute the mix one more time for the last few stippled leaves.

21 Finally, use a sharp knife to scrape a few horizontal highlights out of the water, especially under the rocky area and in other darker areas.

The finished painting.
You can continue to practise painting reflections and
sparkle on water in the next project.

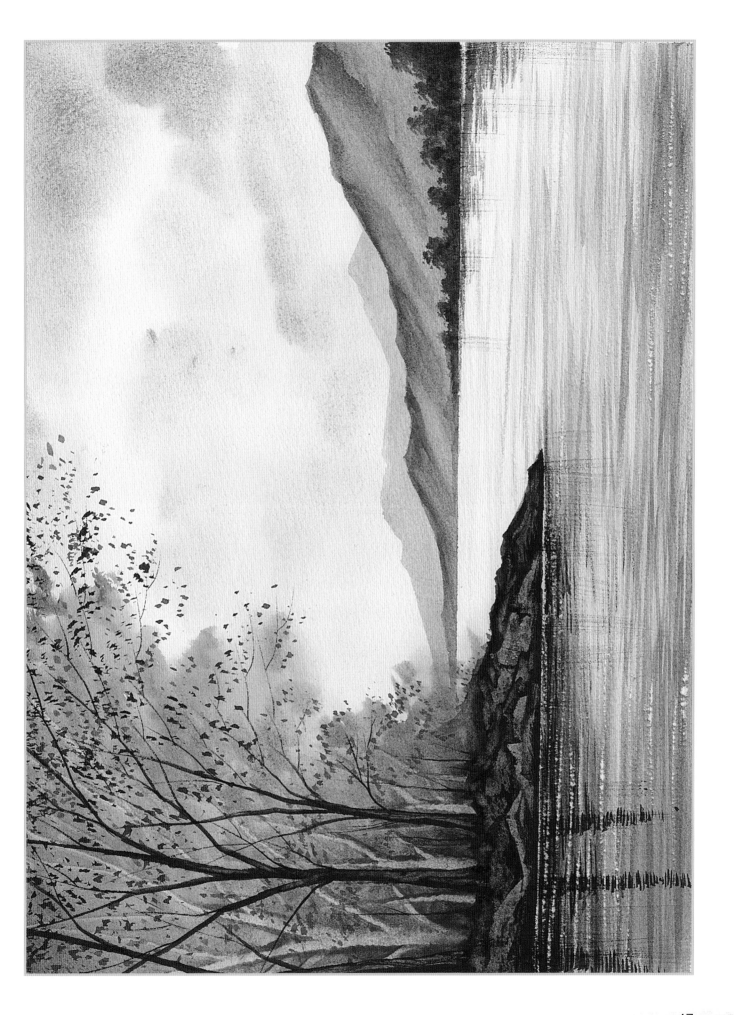

On the Water

What you learn:

- **Portraying tall poplar trees**
- **Painting detailed buildings**
- **Painting detailed reflections in water**

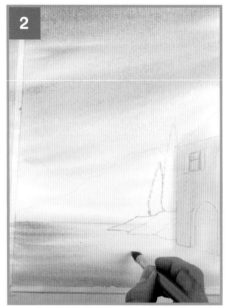

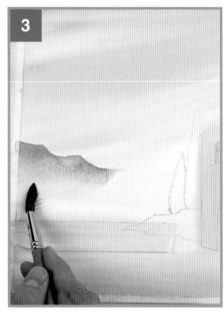

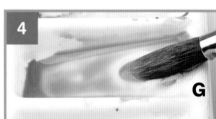

1 The colours and mixes for this project are: French ultramarine (A); alizarin crimson (B); cadmium yellow (C) – pale; pale orange/peach (D) – 70% yellow, 30% red, pale violet (E) – 70% blue, 30% red; pale grey (F) – 60% blue, 10% red, 30% yellow.

2 Wet the paper with the large brush. Start the sky with the yellow (C) behind the mountains, moving up to the top of the sky, then down into the water area. With a clean, damp – but not dripping – brush, put in pale orange (D) halfway up the sky; work the colour down into the yellow, then up from the bottom. Take the orange up over the building on the far right. Change your brushstroke direction from horizontal to vertical to block in the building. Clean your brush, then put in violet (E) across the top of the sky, going down until it disappears into the orange. Add a few horizontal ripples in the water using the same brush and the violet – start from the left. Finally at this stage, pick up a little more pale orange (D) and ensure the whole building on the right is covered, using vertical strokes. Allow this first wash to dry.

3 Mask off the base of the mountain area. With the large brush and the pale grey (F), put in the misty mountain on the left; overlap the right-hand mountain slightly. Bring the paint halfway down the mountain, then with a clean brush blend the colour all the way down to the tape, and over the larger, right-hand mountain. Allow to dry.

4 Mix a pale green (G) from 70% yellow, 30% blue.

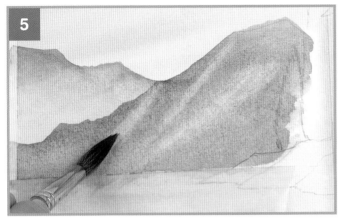

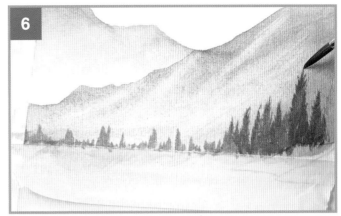

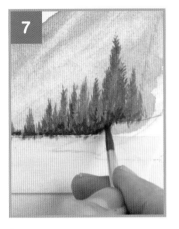

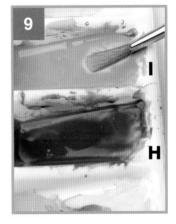

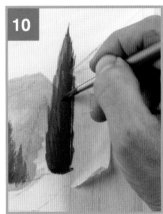

5 Firstly with the pale grey (F) paint over the larger, right-hand mountain. Bring the colour into the poplars on the left of the building. On a clean brush, pick up the pale green (G) and go over the bottom of the mountain. Clean the brush again, squeeze the bristles into a paddle shape, and lift out a few lines to create highlights.

6 Strengthen mix G. With the medium brush, add in the line of distant trees at the base of the mountains – start them off as vertical lines then add a little more detail. Reduce their heights as you work to the left; leave the occasional gap between the trees. Spend more time on the taller, right-hand trees to make their shapes more refined.

7 Add more French ultramarine to darken the green mix (G); with a drier brush add darkness to the base of the trees as diagonal flicks all along the water's edge where the masking tape is. Allow the treeline to dry, then carefully remove the tape.

8 Apply a tiny piece of tape vertically to the left edge of the foreground building, to ensure a straight edge against which you can paint the largest poplar. Add another small piece of tape down the edge of the roof to retain the shape of the overhang.

9 Make two new mixes – a strong dark green (H) from 80% blue and 20% yellow, and a strong yellow-green (I) from 80% yellow and 20% blue.

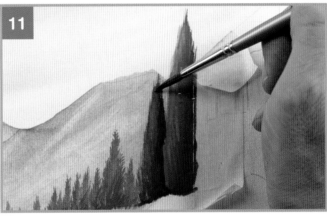

10 Paint the right-hand side of the tallest tree (directly next to the building) in the blue-green (H) from the bottom up; feather the edge of the tree where it meets the sky. Clean your brush then repeat on the left edge of the same tree in the yellow-green mix (I). Blend the two greens together to add darker areas of shadow on the left edge if necessary.

11 Repeat step 10 on the next tree along to the left, starting with the darker green (blue-green mix H). Allow to dry, then remove the two strips of tape from the building.

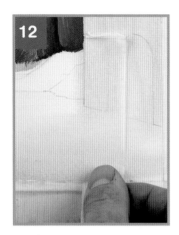

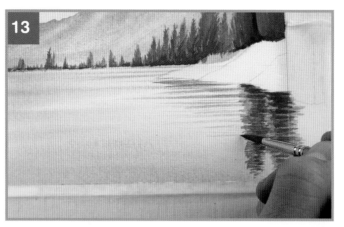

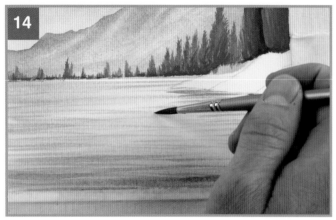

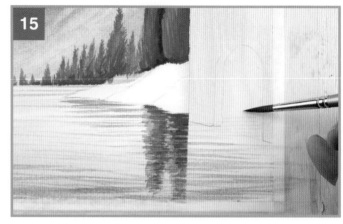

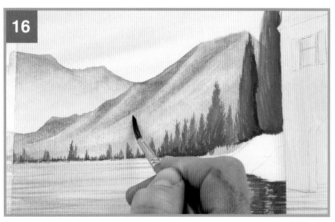

12 Add another tiny, vertical strip of tape to the lower half of the building, running down in to the water area.

13 Dilute the darker green mix (H) and with the medium brush put in horizontal lines beneath the land area to represent the reflection of the tallest tree; take this all the way to the bottom of the paper. Dilute the yellow-green (I) and put in a little of the lighter colour on the left edge of the reflection. Lay in the reflection of the left-hand tree in much the same way but stop the reflection short of the bottom of the paper. Allow to dry, then with the dark blue-green (H) add horizontal ripples around the water, coming out from the treeline. Skim or tickle the paper with the brush to give extra reflection to the distant trees.

14 Using a very diluted pale grey (F) on a fairly dry brush, put in horizontal ripples in the foreground and work backwards – make the foreground ripples larger. Remove the masking tape from the building.

15 With the same grey, add ripples across the previously taped area, going back towards the building and inside the archway opening as well.

16 Use the same pale grey to add a few shadows into the larger of the two background mountains, to the left of the lifted-out highlights, working from the top down. With a clean brush, soften the grey areas into the mountains.

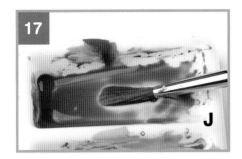

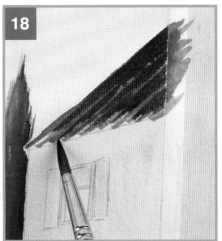

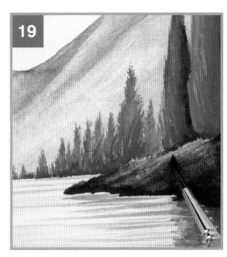

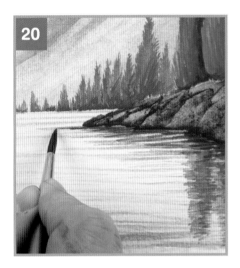

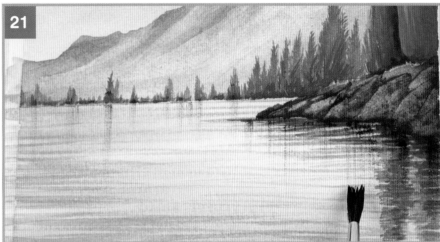

17 Make up a terracotta mix (J) comprising 70% red and 30% yellow.

18 With mix J on the medium brush, paint the roof in the direction of the slope. Leave a few incidental lines to give a tiled roof effect. Add a spot of blue – French ultramarine (A) – to the mix to make it more of a brown; bring this darker colour down over the terracotta of the roof to add character and age. Allow the roof to dry.

19 Make a new, dark brown mix (K) – 50% yellow, 30% red and 20% blue. Use this mix to paint in the rocky mass to the lower-left of the building. Reapply a tiny strip of masking tape to protect the edge of the building. Dilute the terracotta mix (J) and use this to paint over the top of the dark brown rocky area to reactivate the paint before softening the lighter areas.

20 With the corner of a plastic card, scrape away some highlights and details – see page 24. Then, using the dark brown mix (K), add some horizontal ripples below the rocks to ground them in the water. Go over the tops of the reflections of the trees, and beyond the far left edge of the rocks to the left. Remove the masking tape from the edge of the building.

21 Add more blue (A) to the brown mix (K) to make the colour more grey. Splay the bristles of the medium brush and pull down dry-brush reflections all along the water's edge – the less paint, the better.

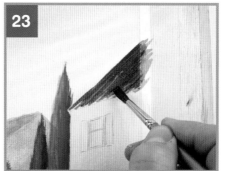

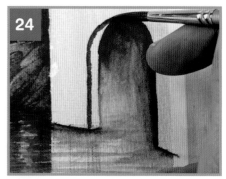

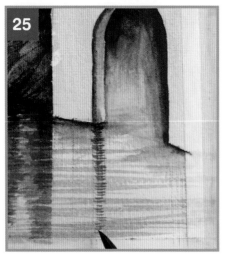

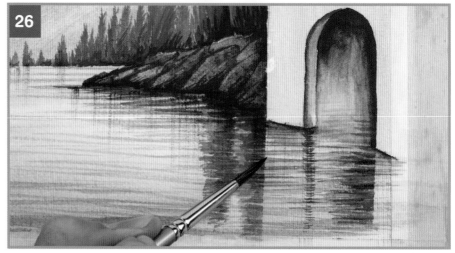

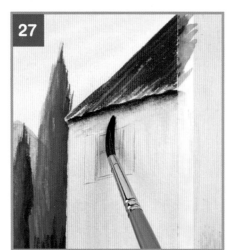

22 Use the same grey from step 21 on a dry, splayed medium brush to add darkness between the rocks and at the base of the trees to give extra shadow. Make this mix quite strong.

23 Put a little dry-brush – with the strong grey – onto the roof as well. Allow to dry.

24 Use the same grey as for the shadows in step 22, making sure it is a strong mix. Paint the inside of the archway from the top, down the right-hand side. Then, with a damp medium brush, blend the colour down and fade it into the water. This gives the impression of an open archway. Add a line of the dark grey to the base of the building, to the left and right of the archway, and blend the colour down into the water. Still with the same dark grey-blue mix, paint the darkness inside the archway, using the colour strongly. Outline the doorway, fill in the top of the recess then with a damp brush pull the colour down to soften it towards the waterline.

25 Put in the reflection of the archway as horizontal lines, using the tip of the brush. Take the reflections all the way down to the bottom of the picture, spacing them out as you move lower down.

26 Run a thin strip of masking tape right down the edge of the building parallel to the doorway then add the horizontal reflections of the archway, which can also go inside the recess itself. Soften the lines to the left with a clean, almost dry brush, then remove the tape again.

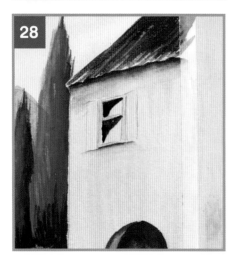

27 Paint in a strong, dark shadow under the eaves of the roof, then feather the shadow downwards with water until it disappears into the face of the building.

28 Put in a strong, grey shadow underneath the window and feather it away; use the same colour to paint the insides of the window panes as triangles; soften these down with a damp brush to fill the rest of the panes.

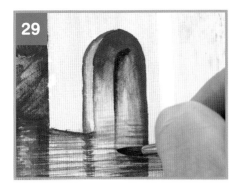

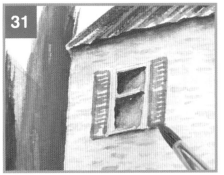

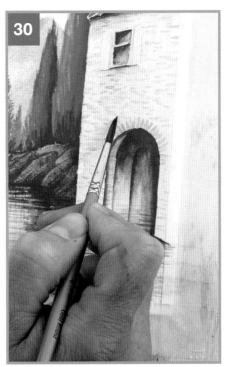

29 Still with the same strong grey, add extra character and an internal arch – beginning with a walking cane shape – inside the recess to create more depth. Wet your brush and soften the colour downwards and to the right.

30 Add some stonework to the building – mix some more pale orange (D) if you need to, and go around the archway to put in keystones. Make single brushstrokes over the face of the building for bricks – this is more than enough detail to give character to the stonework. Go back over the brickwork with pale grey to add a very small number of grey bricks for variation.

31 Come back to the yellowy green from the tree mixes (mix I – see page 49); paint in the shutters as rectangular outlines filled with small horizontal marks. Feel free to use the small brush for extra-fine details.

32 With the small brush, take cadmium yellow (C) straight from the tube and dot flowers around the tops of the rocks and over the bases of the tallest poplars.

33 With the strong, dark grey mix from step 21, add a few darker lines and cracks going into the rocks. You could also put a few birds in the sky at this stage, leaving a gap between the wings for realism.

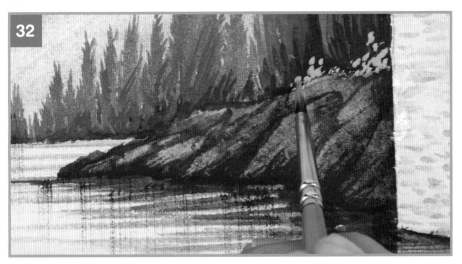

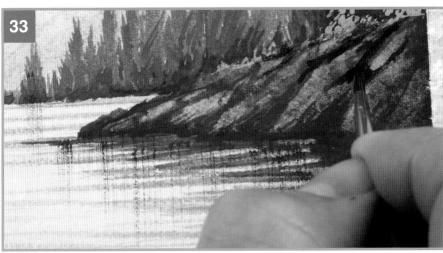

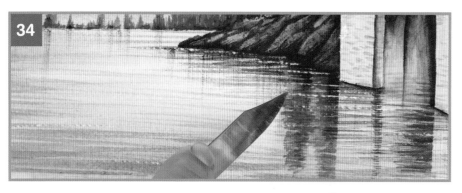

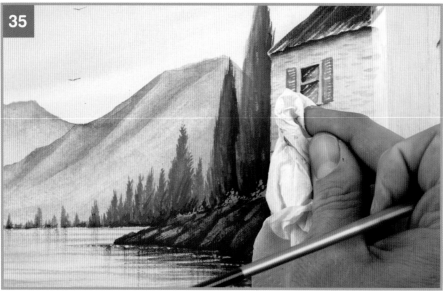

34 Put some horizontal light into the water by scratching with a sharp knife around the base of the rocks and all around the water for sparkle. Put in a few diagonal lines over the window panes for reflections.

35 Finally, lift out a few highlights from the large poplar trees, following the direction of growth; you can also lift out some horizontal lines from the roof to suggest tile detail. Dab away the colour with paper tissue or kitchen paper.

The finished painting.
The final project will bring together many of the techniques you've already learned in this book, combined with a moody moonlight scene.

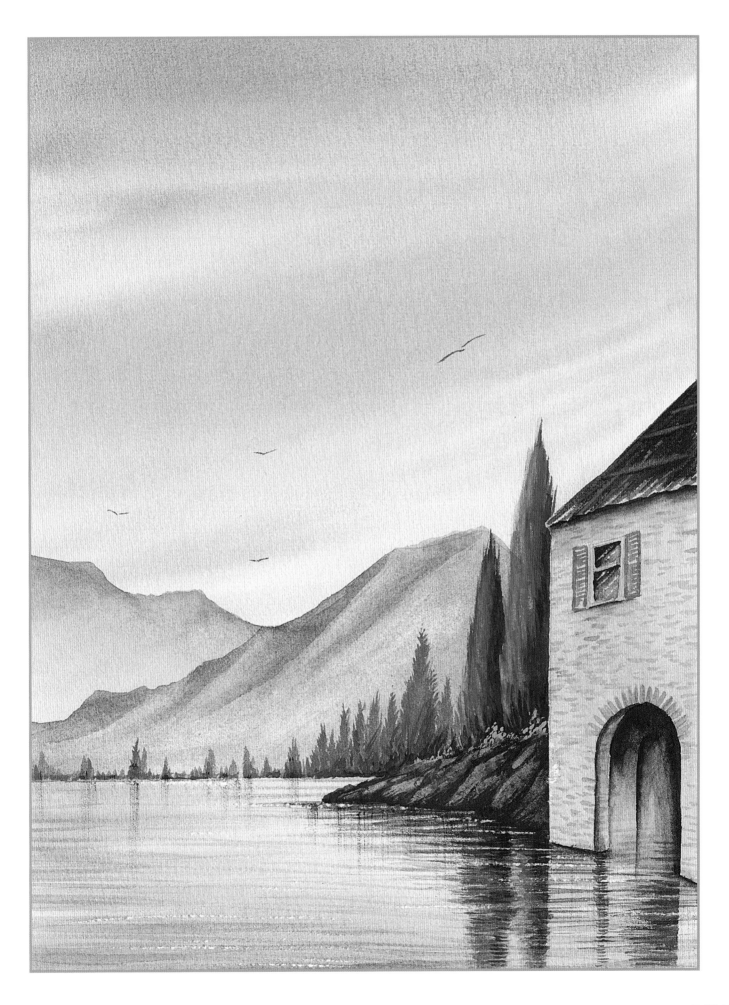

Frosty Night

What you learn:

- Mixing greys
- Painting snow-capped mountains
- Creating an atmospheric moonlit scene
- Scratching out highlights and reflections with a knife

1 The colours and mixes for this project are: French ultramarine (A); alizarin crimson (B); cadmium yellow (C); sandstone (D) – 80% yellow, 10% red, 10% blue; pale violet (E) – 70% blue, 30% red; strong grey (F) – 60% blue, 10% red, 30% yellow.

2 Mask off the tops of the snow-capped mountains with tape – try to get a curve in the tape so that the peaks are not too sharp. With the large brush, wet the paper over the sky area, staying clear of the taped areas. Start by laying in the sky in the sandstone mix (D) nearest the taped peaks.

3 Twist in the violet (E) over the top, then work the colour into the sandstone. Allow both colours to mix on the paper and create variations. Vary the size of the clouds.

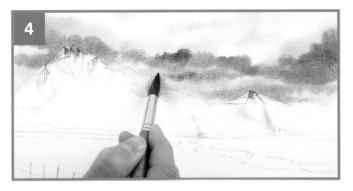

Tip

Avoid going into the top of the sky with pale or watery colours as this may cause cauliflowers (see page 13).

G

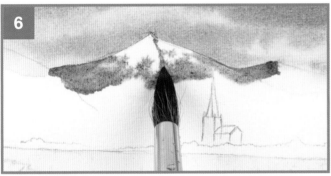

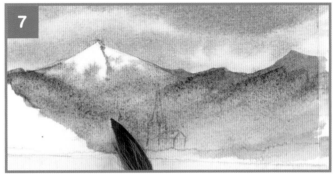

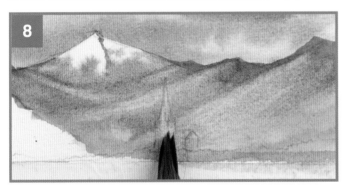

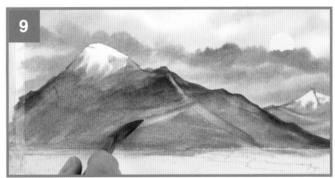

4 Following the instructions on page 11, stamp out a moon with a small coin wrapped in kitchen paper, where the violet and sandstone colours mix. With the strong, dark grey (F) add some darker, more atmospheric clouds – take these over the stamped-out moon, and work finer clouds towards the bottom of the sky. Soften any harsh edges with a damp brush squeezed to a paddle shape. Allow the sky to dry, then remove the tape from the peaks.

5 Mix a strong green (G), 50% yellow, 50% blue.

6 Apply a new strip of masking tape along the base of the mountains. With a large clean brush, wet the top of the right-hand mountain. Take up the grey (F) to block in the mountain, but keep the peak clear. Work the grey all the way down behind the church, using a fairly dry brush but allowing the water to cause a bleeding effect.

7 Wipe your brush almost dry, then work the strong green (G) into the grey at the bottom of the mountain.

8 With a clean brush, drag – or lift – out some light lines coming down from the tips of the mountains, to create separation. Remove a little colour from the top of the church as well, then allow the area to dry.

9 Repeat steps 6 to 8 on the large mountain, using a slightly stronger, heavier mix of grey (F) and lifting out the highlights in different directions to give shape and contour to the mountain.

Tip

When mixing greys, if the colour goes too red add more yellow, followed by a touch of blue. If the colour goes too yellow, add a touch more red followed by a touch more blue.

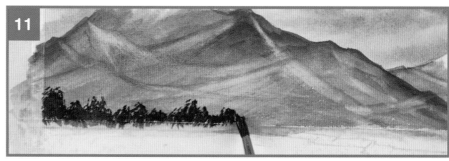

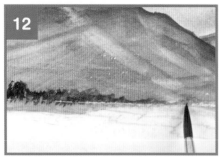

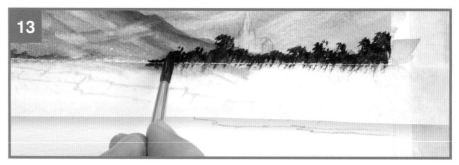

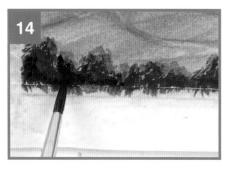

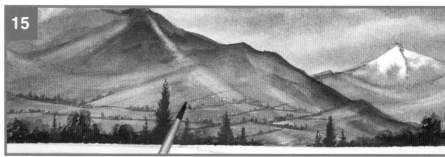

10 Mix a strong brown (H) from 50% yellow, 30% red and 20% blue.

11 With the medium brush, stipple mix H along the base of the mountains and over the green areas to create brown, wintry trees. Make the trees taller on the left and reduce the sizes as you work to the right.

12 When you are halfway across the paper. clean and wipe your brush almost dry, then twist away the tree line to the right so it fades. Add a few spots around the edges of the trees to **diffuse** them (see Jargon Buster) and add to the frosty, wintry effect. Tap the tip of the damp brush to blur the edges.

13 Repeat steps 11 and 12 to bring a second treeline in from the right-hand edge of the paper; soften the end of the treeline and diffuse the edges of the trees in the same way.

14 Take up the dark grey mix (F) from the mountains and add spots of darkness along the bases of both treelines. Use the darker colour to create separation by running spots up the sides of the trees.

15 Darken the green (G) with a touch of French ultramarine (A) on the small brush. Use the brush to put in some pine trees at the base of the mountains – see page 33. Remove the masking tape, then dilute the green mix and use it on the small brush to paint in a few thin, distant field lines going about a third of the way up the mountainsides. Every so often, add in a group of tiny vertical lines for pine trees, to give more distance to the picture. Add in a few of these very fine lines behind the church; the thin lines give more depth. Add a few more spots of green along the field lines to suggest trees.

JARGON BUSTER

Diffusing This is a way of softening any hard edges of paint. As watercolour is easily reactivated with water, clean your brush, tap off the excess on kitchen paper, then tap the damp tip of the brush on the required area to soften it.

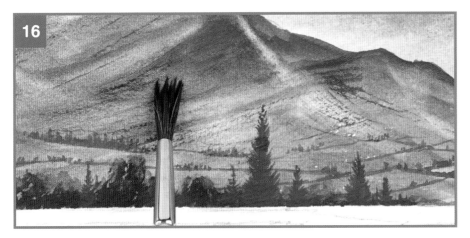

16 Splay the bristles of the medium brush and, with mix H, add a dry-brush effect to the mountainsides. Add the same effect in green (mix G) to the field areas coming down the mountains.

17 Come back to the violet mix from the sky (E – you may need to remix this if you have replaced the colour in the palette). Add a shadow to the left side of the snow-capped area of the larger mountain.

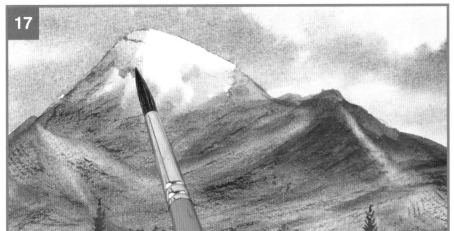

18 Dip the brush in water to clean it, then pull the colour over to the right of the peak to make it look more three-dimensional. Repeat steps 17 and 18 on the smaller, right-hand mountain, but bear in mind that the moon will catch the left-hand side of this mountain so put the shadow in on the right. Allow to dry.

19 Using the sandstone mix (D) block in the whole church, including the spire. Allow to dry, then with the small brush and the strong grey (F), paint shadows on the right-hand side of the church. Darken the sides of the church in solid grey, and suggest the shadowed right-hand side of the spire as a single line. With a clean, damp brush, soften the line on the spire down to the left to make it look rounded. Add a thin line under the eaves of the roof and a couple of spots to represent windows and a clock.

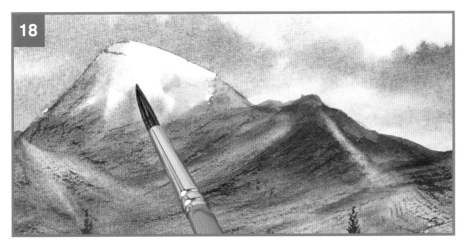

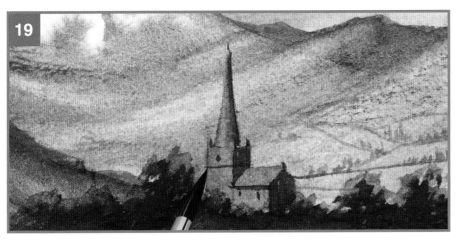

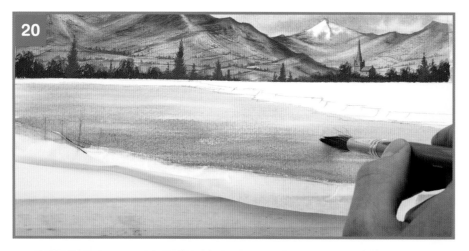

20 Mask off the grassy bank in the foreground, sticking the tape in a slight curve to create hillocks. With the large brush, wet the whole water area. Then, mirroring the appearance of the sky, lay in the original sky mixes – D, E and F – as horizontal reflections in the river.

21 Change to the medium brush. Using grey mix F, add finer horizontal ripples, painting these freely with the tip of the brush. Allow these ripples to dry, then remove the masking tape. Take up green mix G (from the pine trees) and dry-brush horizontal lines below the top edge of the water to reflect the mountains. Darken the green mix slightly with blue (A); splay the hairs of the medium brush and pull down vertical reflections from the base of the trees.

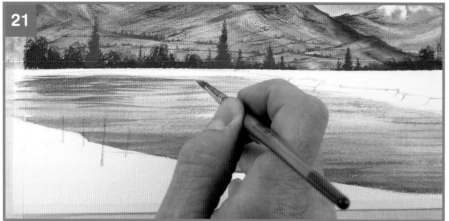

22 Rewet the snowy bank on the right of the river; with a dilute, pale violet (E) on the large brush, work horizontal lines from left to right for a frosty feel.

23 Leave a few lighter areas and work in some green – 50% yellow, 50% blue – with a clean, almost dry brush. Repeat steps 22 and 23 on the left-hand riverbank; darken the green with more blue if required – then with a clean brush, bristles squeezed into a paddle shape, soften any hard edges or lines, and leave the riverbank areas to dry.

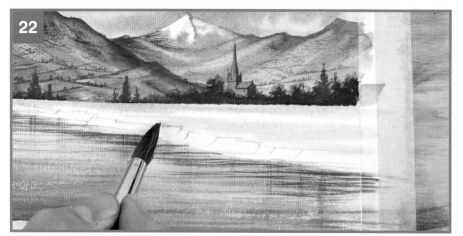

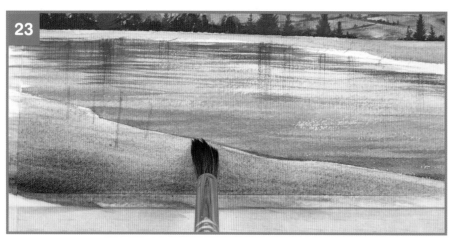

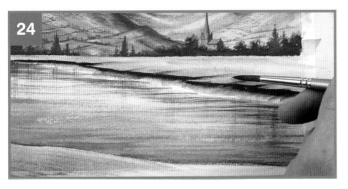

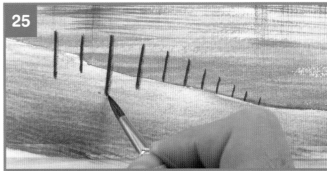

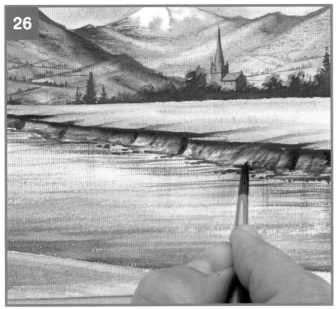

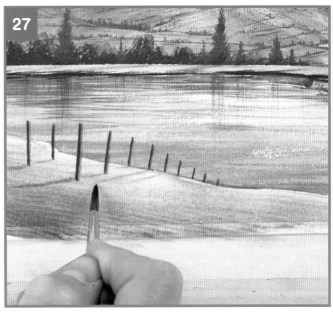

24 Using the medium brush and brown mix H, paint along the eroded bank edge in a zigzag fashion. Add little individual Z-shapes here and there. Make the area slightly thicker in the foreground, and take the line all the way under the water's edge on the left of the painting. Soften down the banking area towards the plane of the water; scrub the colour until it almost disappears. Don't let the brush get too dry as you do this; the points of the Zs should be softened back into the grassy banks so that they disappear. Allow to dry.

25 Use mix H to paint in the fenceposts in the foreground on the medium brush – as many as you need. Create the effect of posts going over and down behind the banking. With a clean brush tip, lift out the right-hand side of each post as if the moonlight is catching it.

26 With the dark grey (F), put in a spotted edge at the base of the eroded bank area for pebbles; add in horizontal lines of spots and dots. Soften the larger pebbles upwards with a damp brush. Paint in the downward drops on the eroded banking where the Z-shapes are – paint a vertical line down towards the water, keeping the grey mix strong. Soften the shadows up to the left with an almost dry brush. The same dark grey can be used to darken the bottoms of the trees.

27 Use pale violet (E) to add some directional shadows from the edges of the trees, using the moon as a point of reference for any change in direction – to the right of the moon put the shadows on the right, for instance. Keep these shadows subtle. Put in some directional shadows from the fenceposts – these should face left.

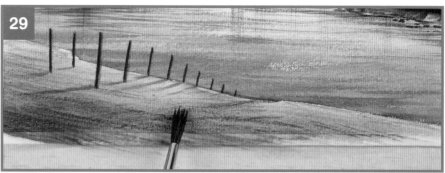

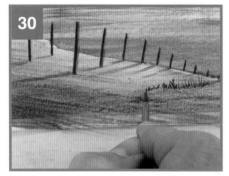

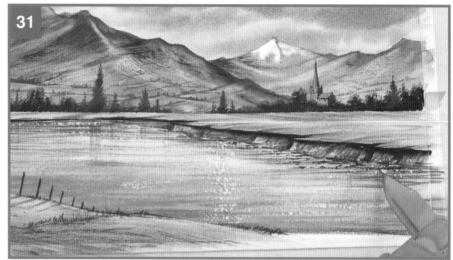

28 Mix a new, dark green (I) – 70% blue, 30% yellow.

29 Go back over the foremost grassy bank with a dry brush, with splayed bristles, to work in a variety of lines for texture and shape. Do the same on the right-hand bank, working back from the water's edge.

30 With the small brush and the same dark green, put in a few tufts and spots of foliage along the water's edge, over the foreground banking, to separate the land from the water.

31 Finally, use a sharp kitchen knife or craft knife to catch the light in the water in horizontal scrapes. Spend time scraping out the reflection of the moon and put a few scratches around the base of the eroded banks for additional pebbles. Don't be afraid to cut the paper surface.

The finished scene.
Go back to your simple mountain painting from pages 12–15 and see how much progress you've made.

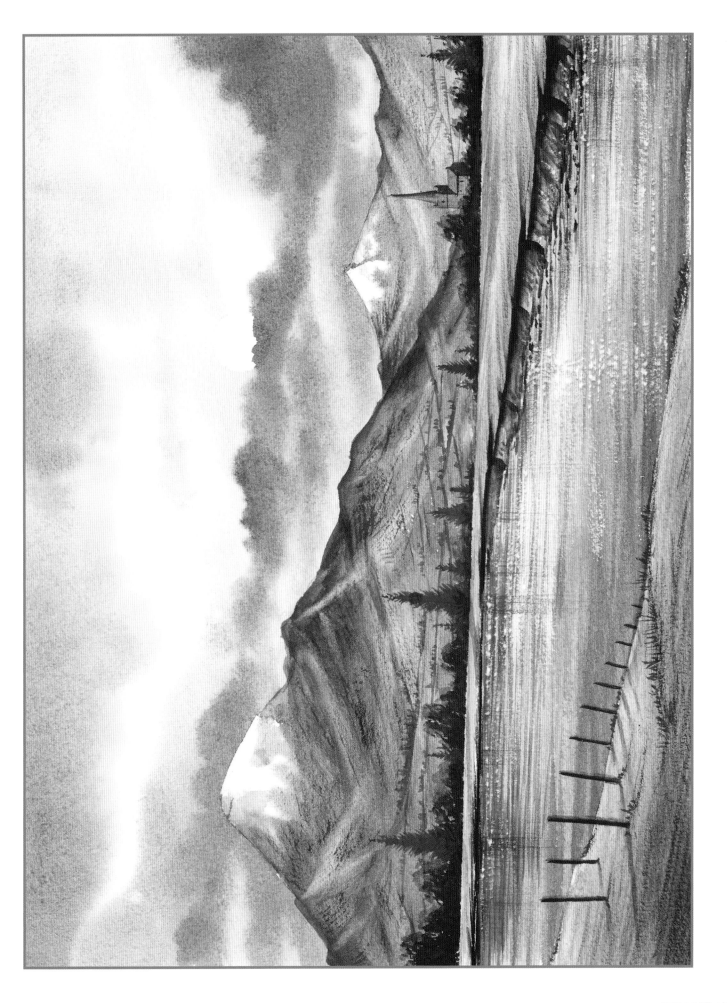

Transferring a drawing

Trace the final paintings for each project and transfer them to your watercolour paper using the method shown here.

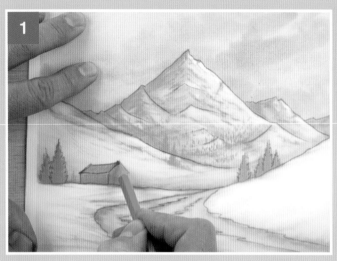

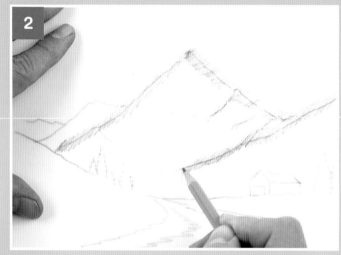

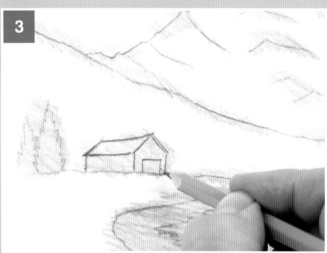

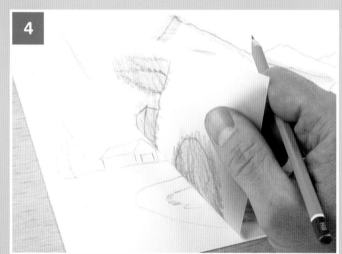

1 Place tracing paper over the image and fix it at the top only with masking tape. Trace the main lines of the drawing as shown.

2 Remove the tracing, turn it over and draw a heavy line over the back of the lines with a soft pencil.

3 Tape the tracing to your watercolour paper and draw over the lines again. The pencil pressure will transfer graphite from the heavy pencil line onto the watercolour paper.

4 Lift the tracing paper. The image might not be perfect and you may need to re-establish some of the lines on the watercolour paper to strengthen them, but it will function as a drawing ready for painting.